IMAGES
of America

JAPANESE AMERICANS
IN CHICAGO

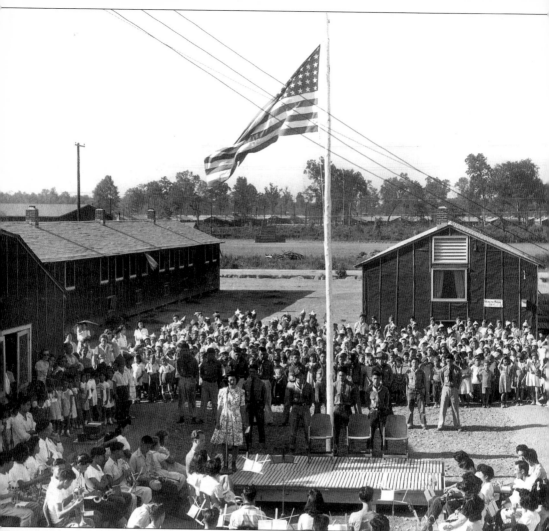

Fumi Itsumi addresses school children at Rohwer Camp. Patriotism was very important and the flag was pledged at the start of each school day. (Photograph by Fred Yamaguchi; courtesy of Yosh Sakai.)

Cover: Nisei Drum and Bugle Corp, sponsored by Nisei Post #1183, march down State Street. What started as a "cute" little group in 1959 peaked into a sought after corps with many national championships. Sats Tanakatsubo remembers one Fourth of July the corp marched in three parades before competing that evening in Evanston. (Photograph by Bob Scholl; courtesy of Sats Tanakatsubo.)

CONTENTS

ACKNOWLEDGMENTS

This photographic book was made possible by the generous assistance of many people and organizations. A tremendous big thanks to photographers who have documented Japanese American history in Chicago through their love of pictures. Bill Adachi, Mary Koga, Ken Mazawa, Thomas Mayahara, Ted Mizuno, Donald Nozawa, Nobuko Oyabe, Yosh Sakai, Bob Scholl, Tak Mizuta, Art Wise, and Fred Yamaguchi graciously lent pictures. Many, many thanks to Jean Mishima, President of the Chicago Japanese American Historical Society (CJAHS), Yoshiko Urayama and Bob Yamane of the Chicago Shimpo, Jeamette McBeth, Director of Heiwa Terrace, and Chiye Tomihiro, Archivist for the Japanese American Citizens League (JACL) for sharing their wonderful treasury of precious photos. Thanks to Robert Karr Jr. for facilitating use of photos from the Chicago Public Library and Chicago Park District. Some images put together by Chiye Tomihiro for the Strength and Diversity exhibit were included. Grateful acknowledgment is extended to Darcie Iki and Mary Doi of the REegenerations Project for the Japanese American National Museum whose earlier oral history work along with the author's collection of oral histories provided a foundation for this book.

Heartfelt gratitude is extended to the many who so generously permitted unique cherished photos from their private collections to be opened and shared: Yae and Bill Adachi, Pat and Yosh Amino, Tatsu Aoki, Ben Chikaraishi, Jean Endo, Jane and Richard Hidaka, Elsa Higashide, Toshi and Kiyo Iha, Ritsuko Inouye, Tomi Inouye, Hiroshi Kaneko, Amy and Morris Kawamoto, Ken Kikuchi, Miwa Marion Krueger, Sunnan Kubose, Frank Matsumoto, Kazue and Thomas Mayahara, Helen Migaki, Tak Mizuta, Itsuko and Ted Mizuno, James Mukoyama, May Nakano, Kazue Natsuhori, Hiroko Nishi, Arlene and Donald Nozawa, Chiyoko Oda, Peter Oda, Ted Oda, Kikue Chris Otake, Joyce Proisie, Masako Takamiya, Sats Tanakatsubo, Joanne Tohei, Dennis Torii, Yone and Chic Tsurusaki, Mitsu and Ted Uchimoto, Miye Yada, Todd Yamamoto, Alyce and Rocky Yamanaka, and Sam Yoshinari. Thanks to Merle Kaneko for lending her Japanese American Yearbooks from 1946 to 1950.

A immense thanks to Hank Ozaki for drawing the Clark and Division map on a shopping bag on the way back from a week-end trip to his Minocque home then continuing work on it. His wonderful sketches were reviewed by Ben Chikariashi, Dorothy and Hiroshi Kaneko, Kazue and Thomas Mayahara, Betty and Jr. Morita, and Howard Yahiro whose collective memories improved the map considerably. Thanks also to my brother, Ned who painstakingly checked the information with available source materials from the 1945–50 time period. The computer assistance provided by William and Kimberly Murata was invaluable especially for the map drawings.

Deep appreciation to Northeastern Illinois University for institutional support. A very special thanks my family for their constant help and support in whatever I undertake. My mother, Hanako Takamiya Murata, and my sister, Arlene Nozawa, are always in the background quietly working very hard without much recognition. Donald Nozawa always develops and helps with photographs. Ned, Bonnie, Kimberly, William, and Michelle Murata always give encouragement as well as service with smiles. Many, many thanks to Arcadia for publishing this book.

INTRODUCTION

Japanese Americans who make Chicago home consider it a most wonderful place to live. They are a very small part of the city's population and many do not know much about this ethnic group, yet their experiences and contributions to Chicago history are considerable. Beginning with their arrival in 1892 to build the Ho-o-den Pavilion as part of the Columbian Exposition, stories of their lives unfold for the first time in print to give glimpses of history from the vantage point of those who lived it. These are photographic views from insiders about their lives.

During the Meiji period, Japan emerged from isolation by sending their most talented men to learn the best of everything from dominant countries. Many of the original Chicago settlers came to study at Chicago universities such as Eji Asada who completed his doctorate at the University of Chicago in 1893. Others were capable entrepreneurs who operated restaurants, gift stores, and housing units. Kamenosuke Nishi had a successful gift store.

A most welcoming city, Japanese Americans were recruited from concentration camps during World War II to accept the many unfilled positions in Chicago. The War Relocation Authority opened its first field office in Chicago to help resettlers. The numbers of Japanese Americans which numbered 390 in 1940 soon ballooned to more than 20,000. When permitted to return to their west coast homes, the numbers of JA diminished. Those that remained in Chicago felt they possessed more of a pioneering spirit and courage to start life anew.

This book is just the start in documenting the history of Japanese Americans in Chicago. It was not possible to do as comprehensive a treatment of this topic as initially intended and many wonderful photos could not be included due to space. It is hoped that future publications will further document with greater breadth and depth the experiences of Japanese Americans in Chicago.

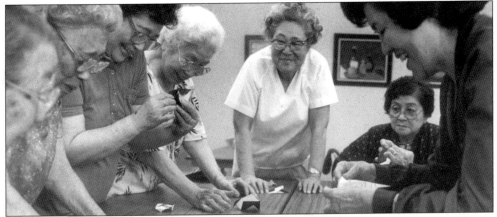

Origami Class at Heiwa Terrace, a HUD facility for seniors. (Photograph by Mary Koga.)

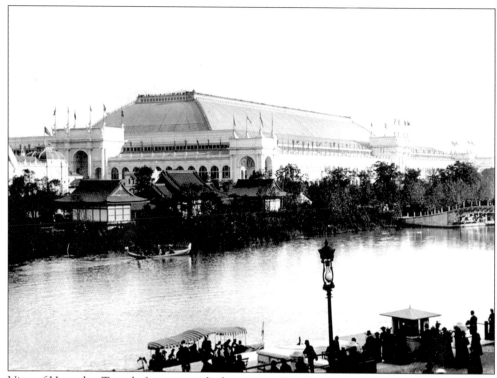

View of Ho-o-den Temple from across the lagoon in 1893. Kazuzo Okamura copied the Ho-o-den and the main structure from the Phoenix Hall of the Byodoin Monastery at Uji built in 1053. After the exposition the complex of pavilions were given as a permanent gift to the city of Chicago. (Courtesy of Special Collections and Preservation Division, Chicago Public Library.)

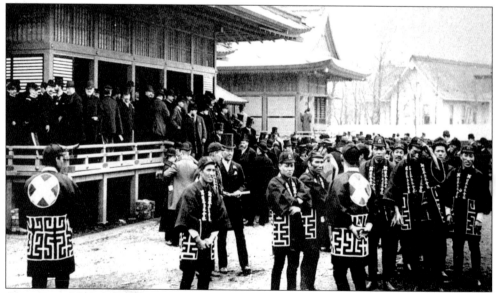

Above is an 1893 Columbian Exposition celebration in front of the Japanese pavilions built by a hundred Japanese workers with native materials. (Courtesy of Special Collections and Preservation Division, Chicago Public Library.)

One

COMING TO CHICAGO AND EARLY YEARS

The first foreign government to give support for the Columbian Exposition was Japan, who committed a half million dollars and the Ho-o-den or Phoenix Pavilion built in the image of the 1053 Byodin Monastery at Uji. Workers from Japan built these structures in Japanese style influencing Chicago architects such as Frank Lloyd Wright, who adopted many Japanese features in his Prairie Style structures. The pavilion was given as a permanent gift to the city of Chicago after the exhibition closed.

Racial prejudice existed in Chicago although not as prevalent as on the west coast. Interracial marriages were forbidden and Caucasian women born in the United States such, as Frances Osato, Bernice Masumoto, and Elenore Torii, found themselves without citizenship after marrying Japanese men ineligible for citizenship.

In 1910 Rev. Shimazu graduated from McCormick Theological Seminary and formed a division of the YMCA to help Japanese students. They purchased a three-story building at 737 E. 36th Street in 1917 for $10,000, and 50 students from Japan lived there from 1918 to 1925 while studying in Chicago universities. This property was lost in 1938 because they were not permitted to own land and didn't own the deed in their own name. Mr. Matsumoto regretted not selling this property for $5,000 when they had the opportunity.

Pre-war residences were scattered throughout the city, and the Japanese community was small but they banded together to socialize and provide emotional support. The Mutual Aid Society of Chicago was formed to assist widows and destitute bachelors who died without family to care for their remains. After Pearl Harbor, additional hardships were faced as their businesses were closed, bank accounts were frozen, FBI interrogated them, were interned, and not permitted to meet in groups larger than three.

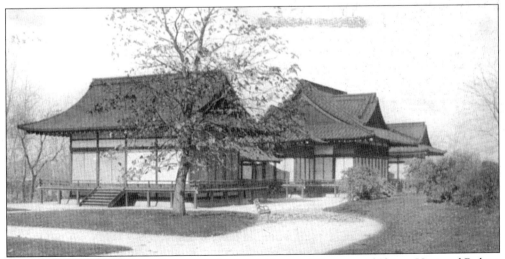

Postcard of 1893 Columbian Exposition Japanese Houses. (Courtesy of Shizuo Hori and Robert Karr Jr.)

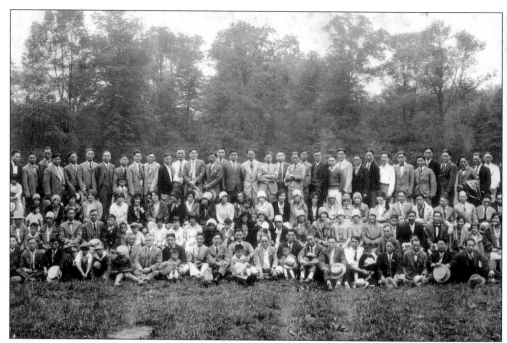

Early Japanese residents of Chicago gathered for a picnic in 1928. (Courtesy of CJAHS, Strength and Diversity Collection.)

The Ho-o-den was renovated and the Japanese garden constructed for the 1933 Century of Progress World Fair. The garden was again renovated in 1981 by Robert Megquier with Kaneji Domoto setting the stonework. Mayor Daley renamed it Osaka Garden in 1992 to commemorate the 20th anniversary partnership between Chicago and sister city, Osaka, Japan. (Chicago Park District, Special Collections photo; courtesy of Robert Karr Jr.)

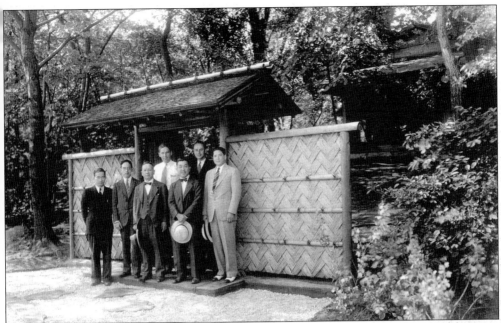

Gentlemen in front of the Japanese Tea House and Garden in 1936. (Chicago Park District, Special Collections photo; courtesy of Robert Karr Jr.)

Jackson Park Tea Garden waitresses in the late 1930s stand next to the Ho-o-den Pavilion, which was erected with funds from Emperor Meiji in 1893 for the Columbian Exposition. Shoji Osato purchased the Japanese Tea Garden and donated it to the Chicago Park District. His wife, Frances Fitzpatrick, operated it with Japanese-American women dressed in kimonos until forced to close at the start of World War II. Jean Endo remembers that her sister worked from age 8 as a waitress ending her shift at midnight and taking the streetcar home alone and that her brother worked for a year as a houseboy for a Hinsdale family at the age of ten. (Courtesy of Natsuhori/Otake.)

This store sold and repaired refrigerators, washing machines, and radios as well jewelry. (Courtesy of Jean Endo.)

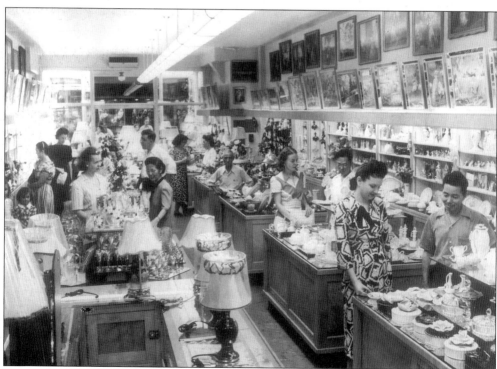

The Otake Gift Shop in the loop had several stores including one in Woodfield Mall. (Courtesy of CJAHS, Strength and Diversity Collection.)

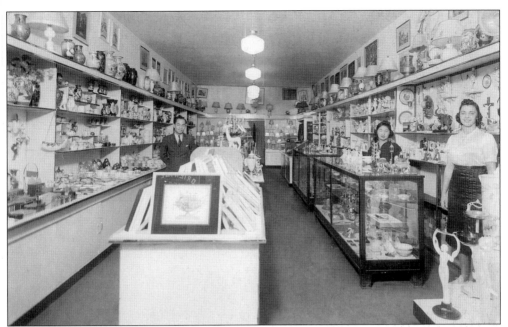

Hidefumi Mukoyama is in his Avenue Gift Shop. He came to Chicago in the late twenties and his brother, Teruo, soon followed and opened Oriental Trading. (Courtesy of James Mukoyama.)

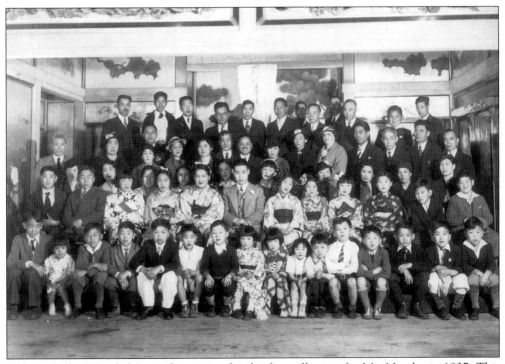

Jackson Park's Wooded Ise is the setting for the farewell party for Mr. Namba in 1937. This photo was taken in the Central Hall of the Ho-o-den Pavilion built in 1893 for the Columbian Exposition. (Courtesy of Natsuhori/Otake Families.)

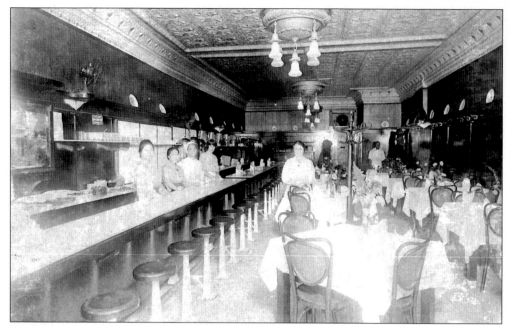

Pictured is the restaurant owned by the Taka and Gensaku Natsuhori. This couple came to America in the early 1900s and returned to Japan in 1908. Childless, they encouraged his brother, who married his wife's sister, to come to Chicago which they did in 1920 to help with their restaurant business. (Courtesy of Natsuhori/Otake Families.)

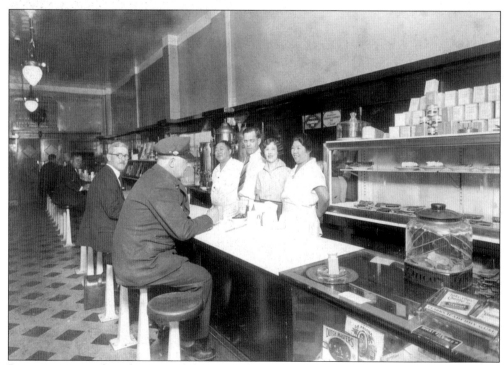

Restaurant owned and operated by Gensaku and Taka Natsuhori, 1920. (Courtesy of Natsuhori/Otake Families.)

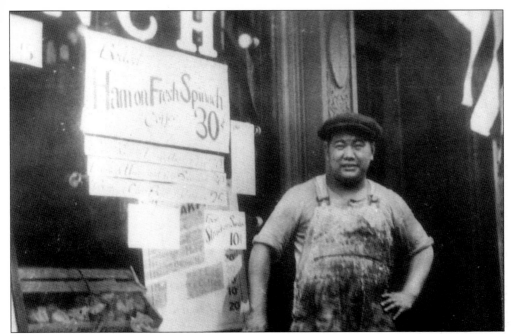

Nakaji Torii stands in front of his first restaurant, Mid City, located on Madison and Des Plaines Avenues. He operated his restaurant 7 days a week, 24 hours a day. After working hard for more than 30 years he sold it in 1955. (Courtesy of Dennis Torii.)

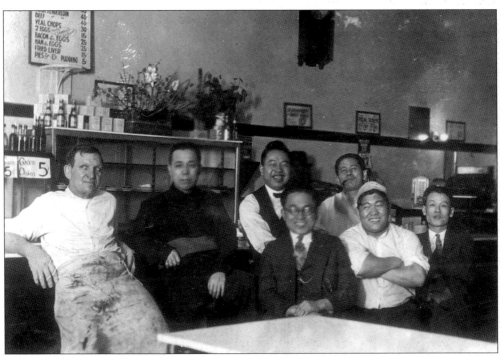

Nakaji Torii with his Issei business partners held interest in several restaurants, some of them numbered Sunrise #1, Sunrise #2, and Sunrise #3, from 1926 to 1930. When the arrangement was dissolved, each took a restaurant to operate independently. (Courtesy of Dennis Torii.)

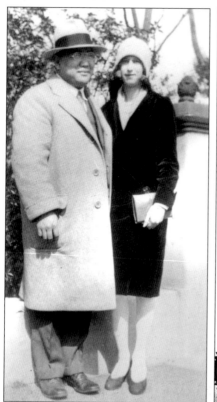

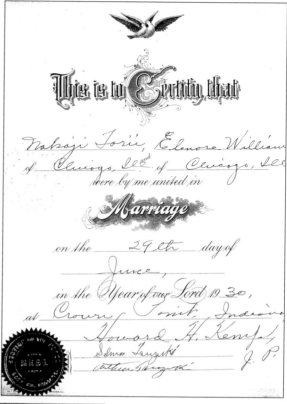

Top Left: Eleanore and Nakji Torii. (Courtesy of Dennis Torii.)

Top Right: Eleanore and Nakaji Torii's wedding certificate shows they were married on June 29, 1930, in Crown Point, Indiana. Although Ms. Torii was born and raised in Chicago, a fourth generation American, she lost her citizenship after this wedding. The Cable Act denied citizenship to American women who married aliens not eligible for citizenship. (Courtesy of Dennis Torii.).

Bottom Left: Birth certificate of Elenore Elsie Williams indicating that she and both her parents were born in Chicago. (Courtesy of Dennis Torri.)

Eleanore Elsie Torii's Alien Registration Form was required by the Alien Registration Act after she lost her American citizenship for marrying an alien not eligible for naturalization by reason of his race. (Courtesy of Dennis Torii.)

U. S. DEPARTMENT OF JUSTICE
Immigration and Naturalization Service
Alien Registration Division
Philadelphia, Pa.

Form AR-573

File No. 5154470

Mrs. Eleanore Elsie Torii
4945 Crystal Street
Chicago, Ill.

April 30, 1943.

The records of this Division indicate that you were registered under the Alien Registration Act of 1940.

From the record it appears that you were born in the United States and registered as an alien because you may have lost United States citizenship by marriage to an alien.

Your attention is invited to the following types of cases which were not required to register under the Alien Registration Act of 1940:

Any U. S. native born woman who married an alien prior to March 2, 1907, is considered to have remained a citizen of the United States providing that she has resided continuously in the United States since such marriage.

Any U. S. native born woman who married an alien on or after March 2, 1907, and prior to September 22, 1922, and whose marital status with such alien has terminated, or who has resided continuously in the United States since such marriage, is not required to register under the provisions of the Alien Registration Act of 1940. In order to enjoy all rights of citizenship, however, such a woman must take the oath of allegiance before the judge or clerk of a naturalization court.

A woman citizen of the United States who married an alien on or after September 22, 1922, did not lose her citizenship by reason of such marriage. However, on or after September 22, 1922, and prior to March 3, 1931, marriage of an American woman to an alien not eligible for naturalization by reason of his race operated to terminate her citizenship, and such a woman was required to register under the Alien Registration Act.

If your case is one of the types described above not required to register under the Alien Registration Act of 1940, and if you have acquired no other nationality by affirmative act other than such marriage, it is suggested that you return to this office your Alien Registration Receipt Card (Form AR-3) and Certificate of Identification (Form AR-AE-23). If you have received one, with a statement explaining which of the above-described types applies to your case. Upon receipt of this information an appropriate notation will be made for permanent retention with your registration record.

GA

DONALD R. PERRY
Assistant Commissioner
for Alien Registration

Naturalization papers for Elenore Elsie Torii show her citizenship was restored on May 10, 1943, with the rescinding of the Cable Act. Extreme pressure was exerted on her by the FBI during the war to divorce her husband, but she remained loyal to him because he was a good provider. (Courtesy of Dennis Torii.)

THE UNITED STATES OF AMERICA

ORIGINAL
TO BE GIVEN TO
THE PERSON NATURALIZED

CERTIFICATE OF NATURALIZATION

No. 5682449

Petition No. 245821

Personal description of holder as of date of naturalization. Age 30 years; sex female; color white; complexion fair; color of eyes blue; color of hair brown; height 5 feet 2 inches; weight 120 pounds; visible distinctive marks None; Marital status Married; former nationality Japanese.
I certify that the description above given is true, and that the photograph affixed hereto is a likeness of me.

X Elenore Elsie Torii
(Complete and true signature of holder)

UNITED STATES OF AMERICA }
NORTHERN DISTRICT OF ILLINOIS } ss.:

Be it known, that at a term of the _____ District _____ Court of
The United States _____
held pursuant to law at _____ Chicago _____
on May 10, 1943 the Court having found that
ELENORE ELSIE TORII
then residing at 4945 Crystal Street, Chicago, Ill.
intends to reside permanently in the United States (when so required by the Naturalization Laws of the United States), had in all other respects complied with the applicable provisions of such naturalization laws, and was entitled to be admitted to citizenship, thereupon ordered that such person be and she was admitted as a citizen of the United States of America.
In testimony whereof the seal of the court is hereunto affixed this 10th day of May in the year of our Lord nineteen hundred and forty-three and of our Independence the one hundred and sixty-seventh.

Elenore Elsie Torii
Seal

Ray H. Johnson
Clerk of the U. S. District Court.
By Zita M. Kearney Deputy Clerk.

It is a violation of the U. S. Code (and punishable as such) to copy, print, photograph, or otherwise illegally use this certificate.

17

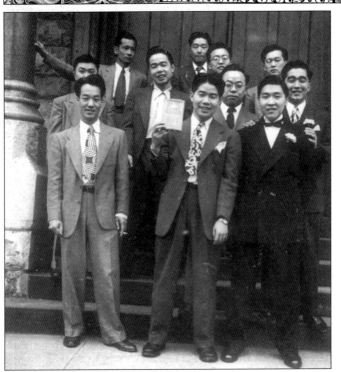

THE UNITED STATES OF AMERICA

ORIGINAL
TO BE GIVEN TO
THE PERSON NATURALIZED

No. 7550467

CERTIFICATE OF NATURALIZATION

Petition No. 357806

Personal description of holder as of date of naturalization: Date of birth September 12, 1899 sex male complexion dark color of eyes brown color of hair black height 5 feet 5 inches weight 180 pounds; visible distinctive marks scar on forehead Marital status married former nationality Japanese

I certify that the description above given is true, and that the photograph affixed hereto is a likeness of me.

albert Nakaji Torii
(Complete and true signature of holder)

UNITED STATES OF AMERICA
NORTHERN DISTRICT OF ILLINOIS } ss:

Be it known that at a term of the ———————— District ———————— Court of The United States

held pursuant to law at ———————— Chicago ————————

on June 21, 1955 the Court having found that

ALBERT NAKAJI TORII

then residing at 4945 West Crystal Street, Chicago, 51, Illinois, intends to reside permanently in the United States (when so required by the Naturalization Laws of the United States), had in all other respects complied with the applicable provisions of such naturalization laws, and was entitled to be admitted to citizenship, thereupon ordered that such person be and (s)he was admitted as a citizen of the United States of America.

In testimony whereof the seal of the court is hereunto affixed this 21st day of June in the year of our Lord nineteen hundred and fifty-five and of our Independence the one hundred and seventy-ninth.

ROY H. JOHNSON
Clerk of the U. S. District Court.

It is a violation of the U.S. Code (and punishable as such) to copy, print, photograph, or otherwise illegally use this certificate.

By Mary Cleland Deputy Clerk.

DEPARTMENT OF JUSTICE

Torii became naturalized on June 21, 1955, and added Albert to his name. The passage of the McCarran-Walter Act in 1952 permitted 88,000 resident Japanese aliens like Torii, who had been in America more than 30 years, to become naturalized citizens. (Courtesy of Dennis Torii.)

Matt, Kei Miura, Rocky Yamanaka, George, Jim, Harry Endo, and Chester Joiichi in front of Elm La Salle Church in the 40s. (Courtesy of Jean Endo.)

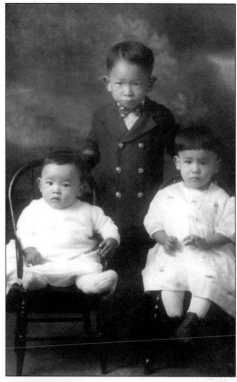

BOARD OF EDUCATION			ED. 3018	

BOARD OF EDUCATION
CITY OF CHICAGO
ELEMENTARY SCHOOLS

MONTHLY REPORT TO PARENTS

LincolnSCHOOL

Report of Scholarship, Attendance, and Deportment of

Iwao YamanakaGrade 5B

for Term Ending*Feb 1*19 37

Month	First	Second	Third	Fourth
English	G	G	G	
Reading	G	G	G	
Spelling	G	G	G	
Writing	A	A	A	
Arithmetic		C		
Geography	G	G		
History	G	G		
Music	G	G		
Drawing				
Physical Ed.	E-			
Physiology				
Nature Study				
Manual Training				
Cooking				
Sewing				
Effort G	G	C	C	
Half Days Absent	0	0	0	
Times Tardy		0	0	
Times Dismissed	G			
Deportment	G	C	C	

(Promoted to Grade 5A)

A. E. Boland, *Teacher*

E means Excellent. P means Poor.
G means Good. F means Failure.
A means Average.

Parent or Guardian will please sign and return.

Above: Iwao Rocky Yamanaka's report card. (Courtesy of Alyce and Rocky Yamanaka.)

Top Right: Iwao Rocky Yamanaka with older siblings Kan and Mary in 1928. Dad was born in 1888 and came to Chicago in 1900 at 14 years old to be a companion playmate to a wealthy Caucasian child in Highland Park. Dad owned a restaurant on Chicago Avenue where the Lawson YMCA now stands. (Courtesy of Alyce and Rocky Yamanaka.)

Right: Kuwahara Christmas card of their two adopted sons, Paul and James. Their father was a photographer who operated Van Dyke Studios at 1225 E. 55th Street. (Courtesy of Natsuhori/Otake Families.)

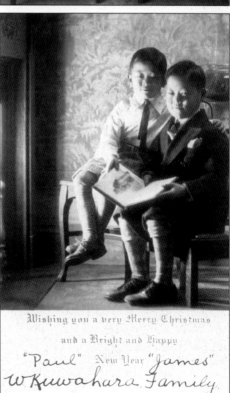

Wishing you a very Merry Christmas
and a Bright and Happy
"Paul" New Year "James"
W Kuwahara Family

19

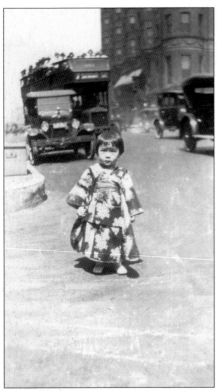

Left: Chris Natsuhori dressed in kimono on the street near her home in 1923. (Courtesy of Natsuhori/Otake Families.)

Bottom Left: Hatsu Yamanaka was a master teacher at flower arrangement, tea ceremony, and koto. A lady ahead of her times, she worked in restaurants and raised three children after her husband died. She learned to drive at age 60 and enjoyed traveling and attending theater performances. (Courtesy of Jean Endo.)

Bottom Right: To help support her family, Asako Endo worked for the Matsumoto Art Shop at 14 N. Michigan Avenue repairing art objects for the wealthy. Her pay was $30 a week without any health or pension benefits. Although poor, she made her home available to bachelors without jobs during the depression and war. She was known as a gourmet cook. In 1960 she quit work to care for her sick husband. This shop was opened in 1920 by Kankuro Matsumoto, who came from Japan to attend school. He graduated from the Chicago Technical College and worked for a year in an engineering office before he started his art repair business. (Courtesy of Jean Endo.)

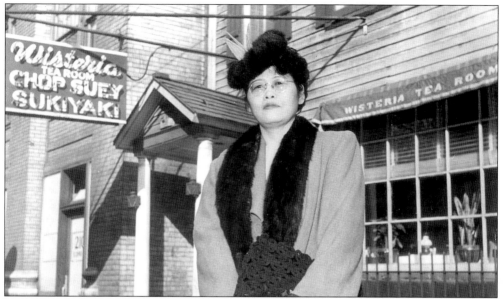

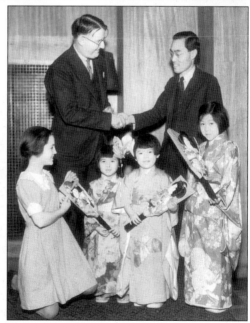

Top: The Wisteria Restaurant, the first restaurant serving Japanese food, was forced to close after Pearl Harbor. (Courtesy of Chicago Japanese American Historical Society, Strength and Diversity Collection.)

Bottom Left: Chris Natsuhori in front of Wrigley Building in 1940. She was working in the Pittsfield Building before the family went to Japan in 1941. (Courtesy of Natsuhori/Otake Families.)

Bottom Right: Kazue Natsuhori, Michiko Saiki, and Kogumi Idaka show off New Year's Hatoita Planks to Consul General Eguchi in winter 1936. (Courtesy of Natsuhori/Otake Families.)

The Masumoto family, Koichi, Teru Isobel, Miwa Marion, and Bessie, on Christmas 1934. Born in 1886, Koichi Masumoto ran away from home at 16 and came to America in 1904. He married his English teacher in Vancouver in 1910 which caused her to lose her citizenship even though she was born in America. The couple tried living in California and then in Japan from 1916 to 1923 before settling in Oak Park with their two daughters. Acknowledging they were different, they adopted the French name of Masmotte, sent the girls to private school, and told them not to mention their Japanese background. Koichi worked for Mr. Yamazaki and Miwa worked for Tom Yamaguchi at Food Mart. In 1939 the couple went to Japan. Bessie returned to the states before the war started but Koichi was not able to do so. She divorced him without telling anyone which made it difficult for him to return to America. When he did in 1947 the couple kept the name of Masumoto because their daughters were adults. (Courtesy of Marion Miwa Krueger.)

The Osato 1937 Christmas greeting card featured Shoji, Frances, Sono, Teru, and Tim. This family came to Chicago in 1925. After war with Japan was declared, Mr. Osato was interned with several Germans in a south side building for ten months. During this time his wife moved to New York and when he was released would not let him join her. He died in Chicago in 1954. (Courtesy of Natsuhori/Otake Families.)

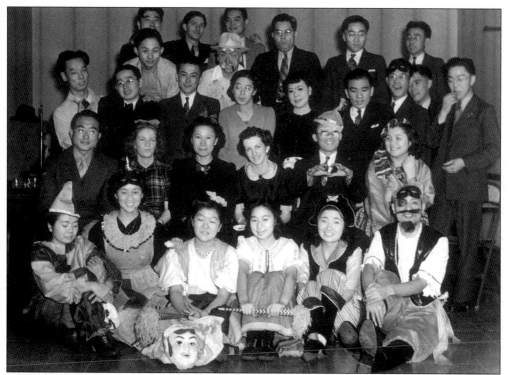

Youth socialized at the University of Chicago's International House in the 1940s. (Photograph by Ken Mazawa.)

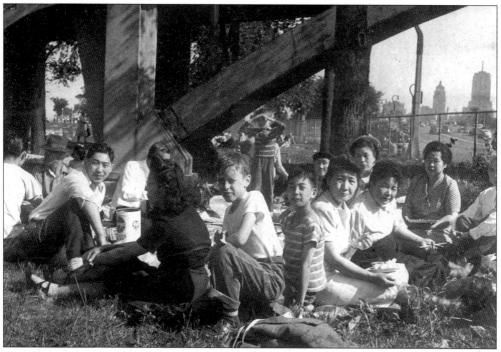

Lincoln Park picnic with a nice view of the Chicago skyline. (Courtesy of Jean Endo.)

23

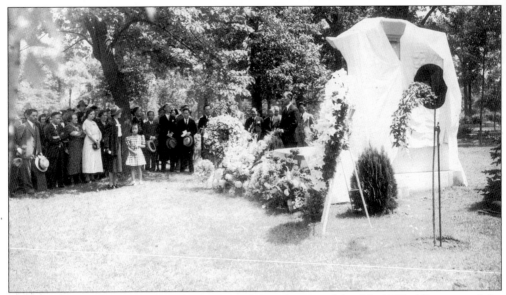

Montrose Cemetery—unveiling the Japanese Mausoleum on May 30, 1938. (Courtesy of the Chicago Japanese American Historical Society, Natsuhori/Otake Collection.)

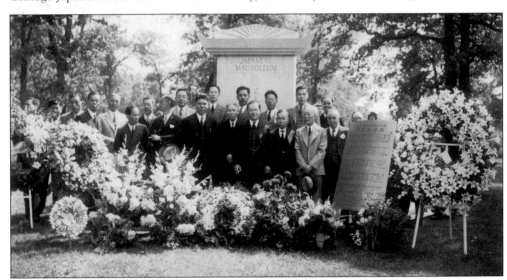

Pictured is the unveiled Mausoleum at Montrose Cemetery. Initially Japanese Americans could be buried anywhere and, because no records were kept, the location of many are unknown. In 1948 a problem with burials was identified by Tats Kushida at the Conference on Civic Unity sponsored by the Chicago Commission on Human Relations. The Mutual Aid Society's plots at Montrose were filled and Japanese Americans were refused burial in Chicago cemeteries. Drew Pearson wrote an article drawing attention to this situation and indicated provisions in state charters granted in the previous century to cemeteries making it impossible to break discrimination. Restrictive clauses established in 1905 were upheld until the Supreme Court ruled against restrictive covenants. On March 9, 1949, the Mutual Aid Society negotiated to purchase additional lots at Montrose Cemetery and their fund drive for $3,000 was successfully met by raising $5,416 within ten weeks. (Courtesy of the Chicago Japanese American Historical Society, Natsuhori/Otake Collection.)

Unveiling the Japanese Mausoleum erected by the Chicago Japanese Mutual Aid Society after successfully raising $4,000 from the Nikkei community. This group was organized in 1934 to aid and relieve resident Japanese, promote welfare, elevate character, foster goodwill among Japanese residents, and contribute to the development of the community. Many single bachelors passed away without any money or family members to take care of their funerals. During their first 11 years they handled more than 70 funerals of persons without relatives and gave aid to many injured and feeble persons. (Courtesy of the Chicago Japanese American Historical Society, Natsuhori/Otake Collection.)

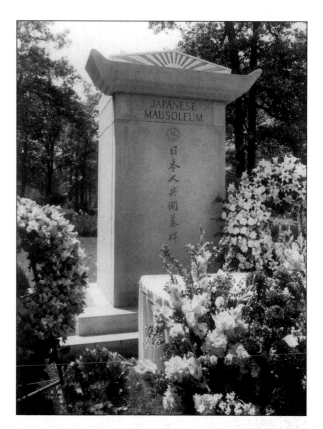

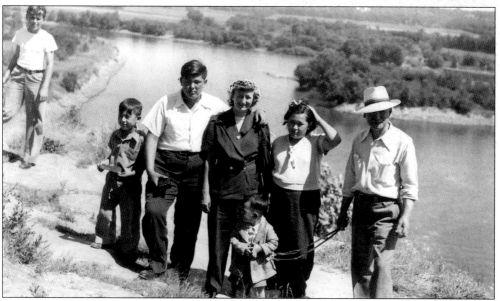

The Torii Family, Dale, Ron, Eleanor, Dennis, and Joyce with friend and father's partner, Tom Yamachi at Starved Rock. Mr. Yamachi owned a restaurant north of the Chicago Theatre which was confiscated when the war began. He sold it in a quick sale and changed his name to Tom Wong. (Photograph by Nakaji Albert Torii.)

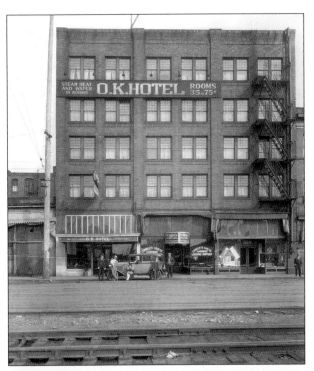

Eizo Nishi married and had a son, Toshio, in 1931 when he invested his savings on the OK Hotel with rooms renting for 35¢ to 75¢ a night. (Courtesy of Amy Kawamoto.)

Eizo Nishi sits in his new car carrying his son, Toshio, while his wife, brother Misaka, and friend admire them. After the war Nishi owned buildings in the Oakenwald area of Chicago. (Courtesy of Amy Kawamoto.)

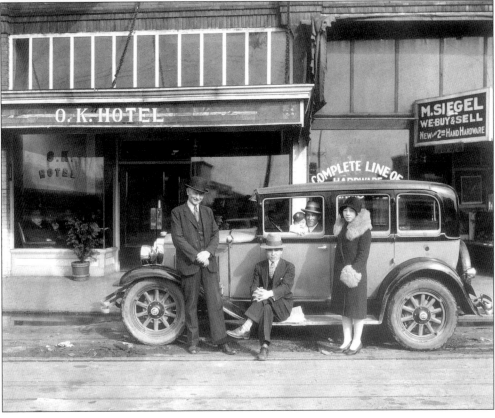

Two

OTHER PATHS TO CHICAGO

The first Japanese immigrants came as contract laborers to work in the sugar fields of Hawaii in 1865. On the mainland they labored to build railroad tracks, harvest lumber, mine coal, fish, and farm. Many students worked for Caucasian families while they attended school. Faced with racial discrimination they resided in segregated communities with those of the same ethnicity. By the start of World War II they were beginning to gain success in farming, fishing, and operating small businesses.

After Pearl Harbor was attacked, President Roosevelt signed Executive Order 9066 on February 19, 1942, forcing 120,000 Japanese Americans mainly from California, Oregon, and Washington into ten concentration camps; Gila River, Granada, Heart Mountain, Jerome, Manzanar, Minidoka, Poston, Rohwer, Topaz, and Tule Lake. Their losses were great as they sold their belongings for a fraction of their true value. As soon as permitted, Japanese Americans left the camps. They assisted in harvesting crops and went to Midwestern cities such as Chicago to take jobs and assist in the war effort. The amicable racial climate made living in Chicago comfortable.

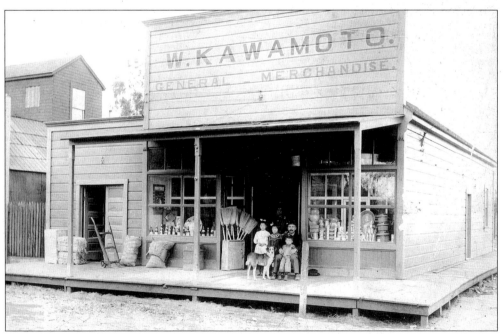

Waichi Kawamoto and his children pose in 1906 in front of his General Merchandise Store in Florin. He died young of pleurisy leaving his wife to raise their children. The youngest son, Takeo, was sent to live in Japan and returned to America when he is 17 years old. In Chicago Takeo owned buildings and a family drapery business. (Courtesy of Kawamoto Family.)

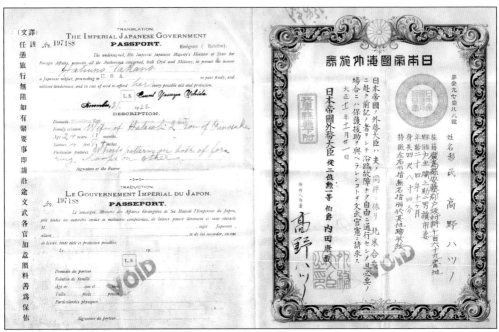

The Japanese passport of Hatsuno Takano shows she came to America in 1922. Hataichi Takano returned to Japan after his first wife died to seek another spouse to help raise his three young children. Ms. Takano had also been married and lost her first husband. The couple worked in the grape fields of Parlier, California, before the war. Ms. Takano cried because her partner loved to gamble and play *hana*, a Japanese card game, and seldom took her anywhere. She longed to see movies. Ms. Takano lived to be 102 years old. (Courtesy of Jean Mishima.)

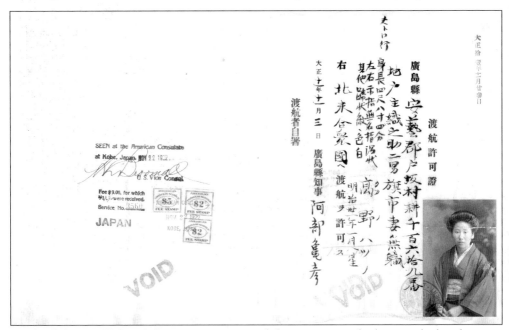

Inside of Hatsuno Takano's Japanese passport with her portrait in the lower right-hand corner. (Courtesy of Jean Mishima.)

Eizo Nishi worked for ten years lumbering in Snoqualmie, Washington, with a sizable number of Japanese-American men. He is shown here with coworkers on April 12, 1921. (Courtesy of Amy Kawamoto.)

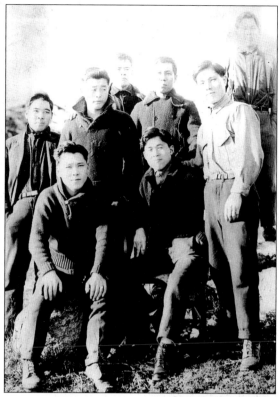

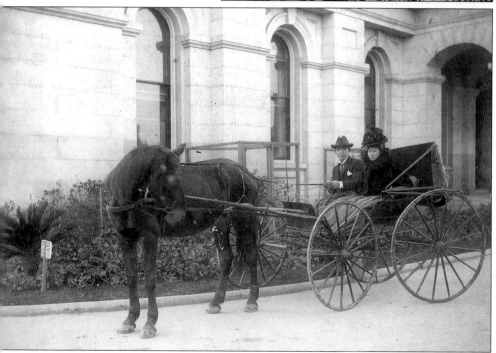

Waichi and Mine Kawamoto appear to be prosperous in 1905 as they sit in their horse and buggy in Sacramento. (Courtesy of Kawamoto Family.)

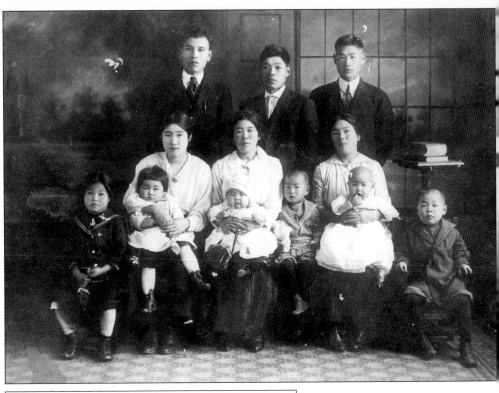

The Masaye and Shintaro Takamiya Family with extended family members in California on Oshogatsu New Year 1920. (Courtesy of Murata Family.)

Shintaro Takamiya's berry basket contract, made on November 8, 1913. Because Alien Land Laws prevented him from purchasing agricultural land and restricted him from leasing land for more than three years in a row, he continuously had the difficult chore of preparing land to farm in the Gardena, California area. (Courtesy Murata Family.)

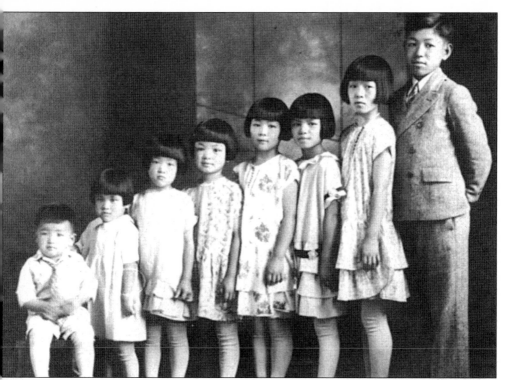

Sanji Inouye's children in Salem, Oregon, in the 1930s. Dad grew hops in Oregon. (Courtesy of Ritsuko Inouye.)

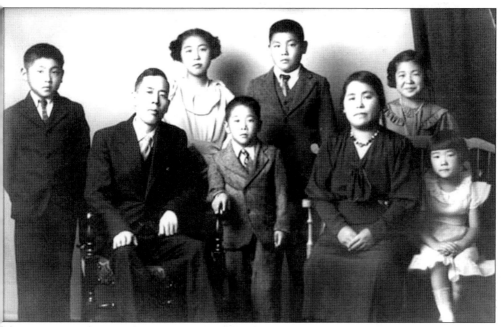

The Tom Kawako Family in 1936 when daughters Miye and Toshi left Seattle for Japan. Kawako came to America in 1917 and had a restaurant business. After release from Minidoka Camp he opened up a restaurant in Chicago. (Courtesy of Miye Yada.)

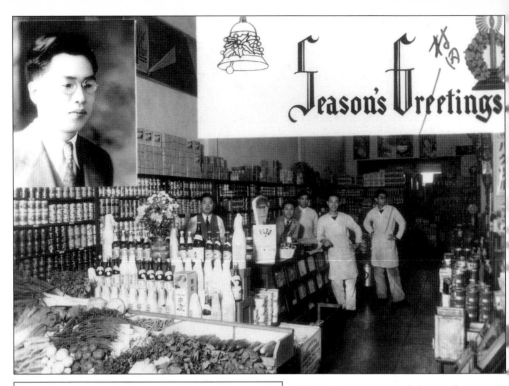

Teruo Murata owned the produce part of this Los Angeles Grocery Store in 1935.

Even though Matsuchi James Koyama was born in Hawaii on August 13, 1892, served in the military during World War I, and obtained reference letters from employers about his character he was still forced into a concentration camp. He took a picture bride in 1918, and after divorcing her in 1928, he devoted himself to raising his only son, Shigeki, born on February 3, 1920, as a single parent.

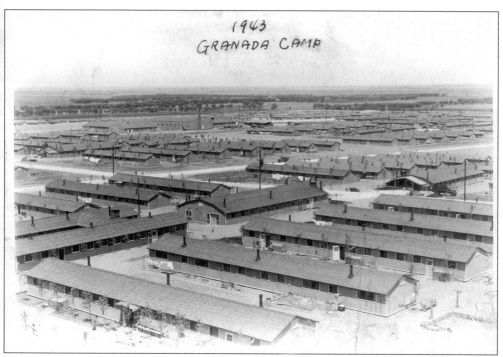

Granada Camp barracks, which were similar to barracks in all the camps. (Courtesy of Don Nozawa.)

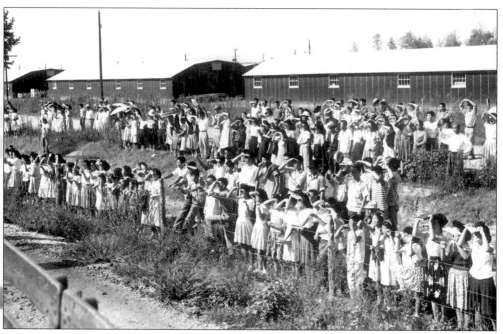

Rohwer Camp residents wave goodbye on this sad day as some Japanese Americans were taken to Tule Lake. Japanese Americans were placed behind barbed wire with soldiers pointing guns at them even though two-thirds were American citizens and nobody was charged with doing anything wrong. (Courtesy of Yosh Sakai.)

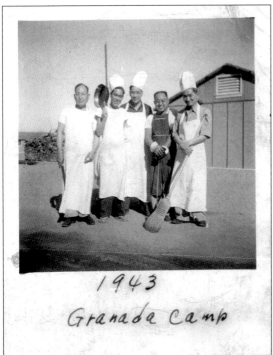

1943
Granada Camp

Cooks of Granada Camp in 1943. Internees worked for $16, $19, or $21 a month keeping the camps operating while Caucasians doing the same work were paid much more. They would have preferred to work outside camp where earnings averaged $55 a week. (Courtesy of Don Nozawa.)

Lines were required for everything, including meals in mess halls at Rohwer Camp. Still, Yosh Sakai had fun in camp spending his days following his passion for photography and judo.(Photograph by Yosh Sakai.)

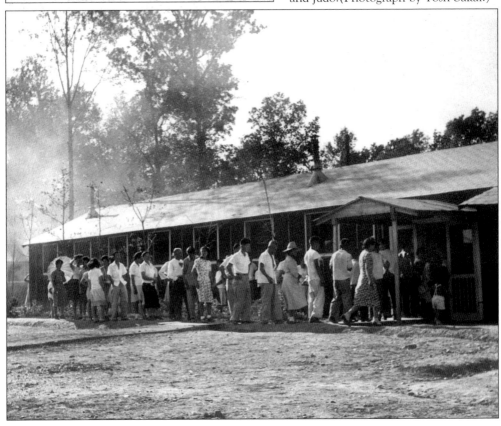

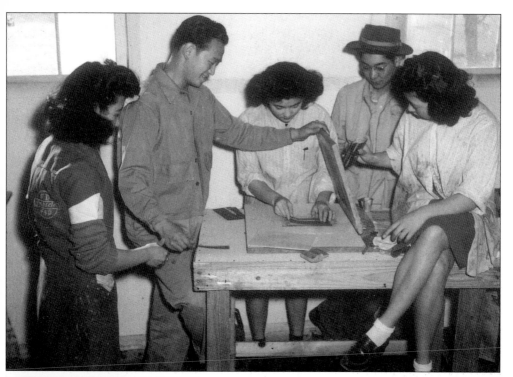

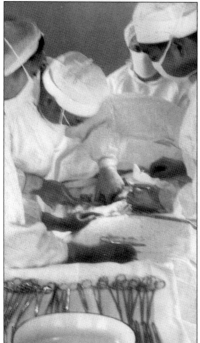

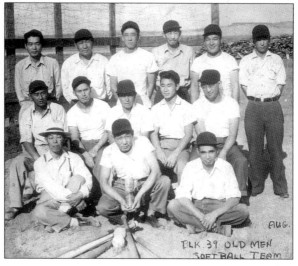

Above: This Silk Screen Poster Shop at Amache Camp is where Thomas Mayahara and his co-workers Maize Asakawa, Bill Kawada, and Cowl Takao made posters for the U.S. Navy. Mayahara used this knowledge in photography and silk screening to make a living in Chicago. (Courtesy of Tom Mayahara.)

Below: Block 39, Old Men's Softball Team at Tule Lake Camp, August 1943. (Courtesy of Helen Kawamoto Migaki.)

Above: Mastectomy operation by Dr. Ikuta with Dr. Hasegawa assisting. (Photograph by Fred Yamaguchi; courtesy of Yosh Sakai.)

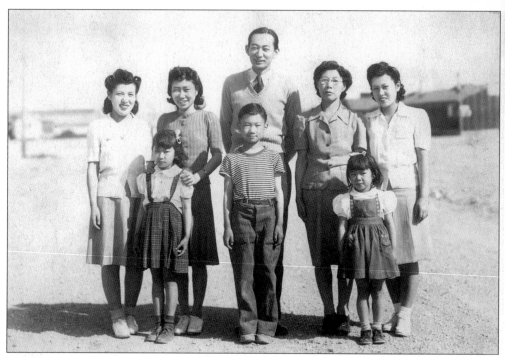

The Kawamoto Family, interned at Tule Lake, is pictured in front of barracks. (Courtesy of Helen Kawamoto Migaki.)

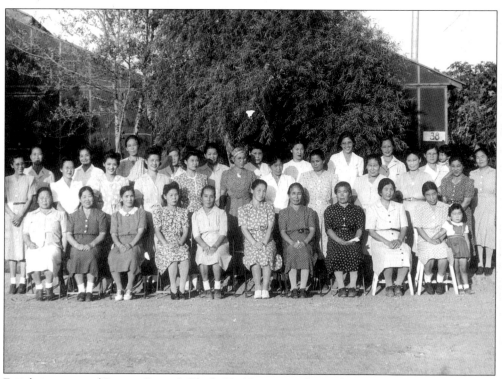

Fujinkai women of Poston Camp I, Block 38. (Courtesy of Hanako Murata.)

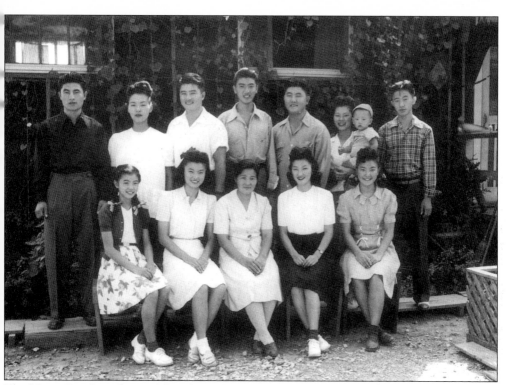

The Hagio Family in front of their barracks in Rowher. Dad is missing because he was sent to another camp. After Allan Hagio left General Mailing, he opened Graphic Finishing and Mailing Company on Jackson Street, which family members continue to operate today. (Photographer by Fred Yamaguchi; courtesy of Yosh Sakai.)

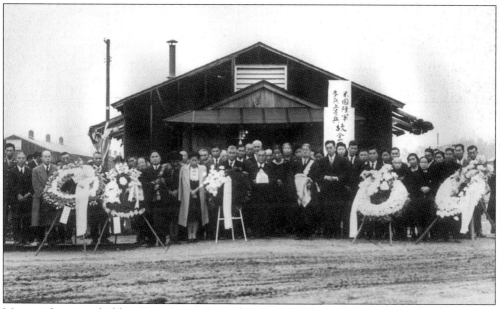

Memorial service held at Jerome on December 8, 1944, for a 442 veteran who died in the European theater of war. (Courtesy of Masako Takamiya.)

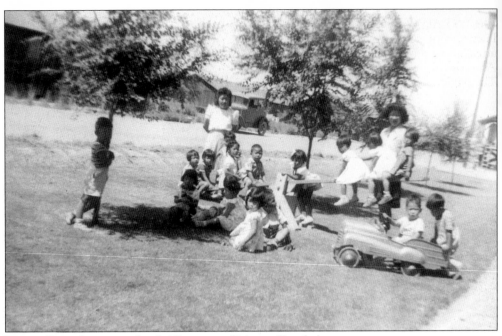

Poston Camp I nursery school. (Courtesy of Murata Family.)

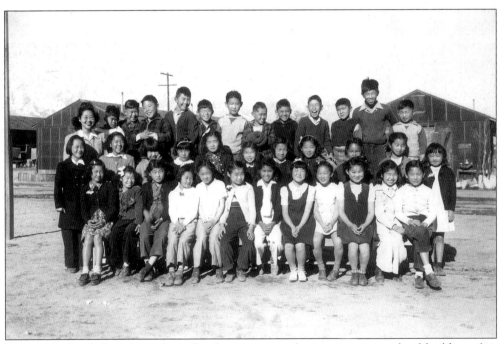

Manzanar school class photo. Initially, there were no plans to construct school buildings, but because internees wanted an education, school opened on October 15, 1942, without any curricula, supplies, or furniture, and a shortage of teachers. Amino remembers Manzanar as a hot and dusty place with old retired teachers that were really, really bad and others that were really, really good. As a 13 year old, he enjoyed playing football, baseball, and basketball after school. (Courtesy of Yosh Amino.)

The 1945 Amache High School Queen, Lucy Nakano, is surrounded by her attendants, June Sato, Fumi Sotomura, Asano Kasai, and June Oda. (Courtesy of Thomas Mayahara.)

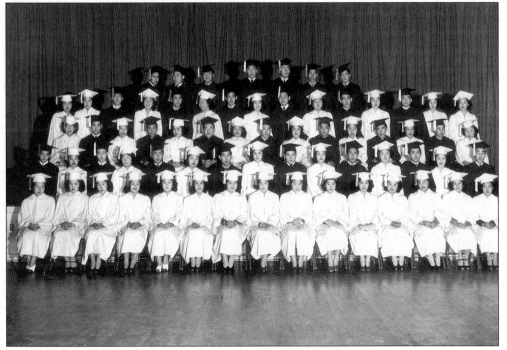

The largest Amache High School Graduation Class was in 1945. Among the Chicago area residents who graduated that year are Tsugi Mayahara, Mits Ikeda, Shige Fukuda, and Fumi Morita. (Courtesy of Tom Mayahara.)

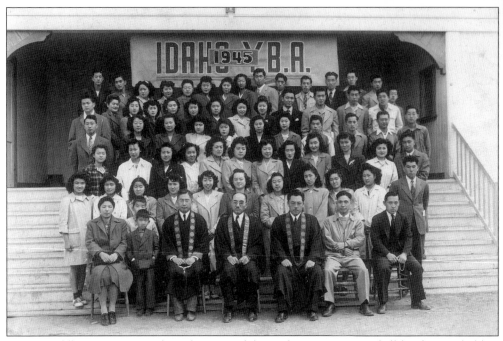

Young Buddhist Association (YBA) in Minidoka. Religious services of all kinds were held in camp. (Courtesy of Kazue Mayahara.)

A wedding reception in Haney, British Columbia, in 1939 upon the return from Japan of Masao Kawamoto with his new bride, Hisako Soga. Masao was born in Canada in 1909 and worked as a lumberjack and in farming until World War II when the family was evacuated to an Indian Reservation at Lillooet, British Columbia, where May was born on May 31, 1943. At age 25, she transferred to the Merrill Lynch Office in Chicago. She married Hiroshi Nakano, and had two children, Megan and Matt. (Courtesy May Nakano.)

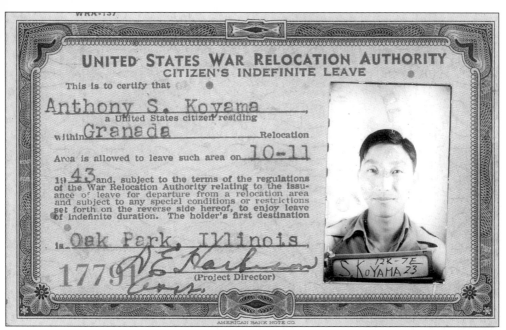

To leave camp, a Citizen's Indefinite Leave Card was necessary along with a job in hand. This card for Anthony S. Koyama indicates he was a resident of Camp Granada with permission to leave for Oak Park on October 11, 1943.

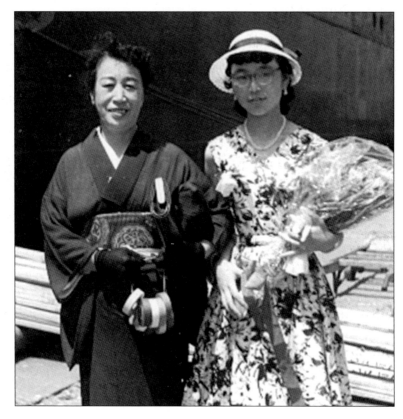

Itsuko Mizuno and her mother bid good-bye as she boards a ship to America for biblical study in 1955. She was in Kansas for a year before she entered Garrett Theological Seminary in Evanston.

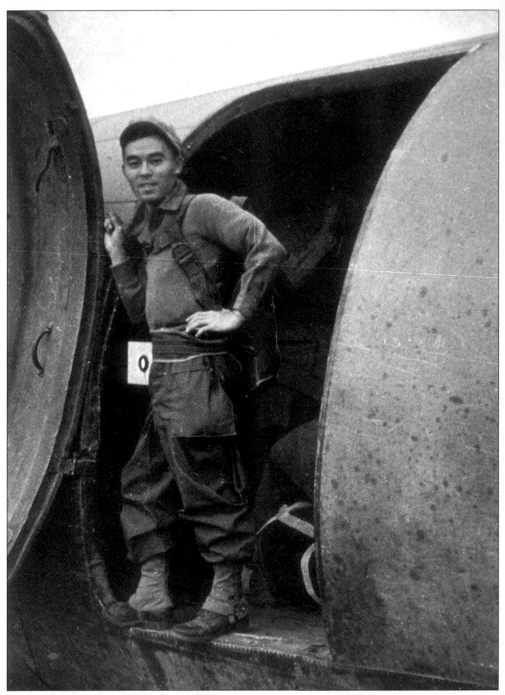

Ken Mazawa stands at the plane door before parachuting into the Burmese Jungle to join the Kachin Rangers. A fellow team member, Tom Chamales, authored *Never So Few* about their military adventures in Burma, which was made into a movie with Steve McQueen playing Mazawa and Frank Sinatra his CO. (Courtesy of Ken Mazawa.)

Three

MILITARY SERVICE

Even though Japanese were not permitted citizenship they have served in the United States military from the time they arrived. The first to serve was Hizako Hamada who was an interpreter for the American consulate in Kanagawa, now Yokohama, in 1862. Two Japanese graduated from the United States Navy Academy at Annapolis in 1877. Nine Japanese were on the Navy battleship, *USS Maine* when it was blown up in 1898. Nikkei served in every war since the Spanish-American War. Nakaji Torii joined the British Merchant Marines before World War I and served on the War Wolf. When the war ended he was discharged in England and sailed around the world twice on various sailing ships. He stopped in Chicago in the middle 1920s on his way back to Japan and stayed. Koichi Matsumoto, an early Chicago resident, served in the Infantry in World War I and II.

Chicago Japanese-American men volunteered to serve in special units during World War II even though their families were interned. They were part of the 100th Infantry Battalion known as the Purple Heart Battalion because they earned thousands of purple hearts. The 442nd was formed in 1943 to fight in Europe and was best known for rescuing the Lost Texas Battalion suffering 814 casualties and 141 deaths in the process. There were 18,142 medals earned such as the two Silver Stars and three Purple Hearts by Sam Yoshinari. The Military Intelligence Service (MIS) staff were attached to every Pacific unit and served by translating documents, interrogating prisoners, and deciphering enemy orders. Japanese Americans soldiers earned equality by shedding blood for the United States.

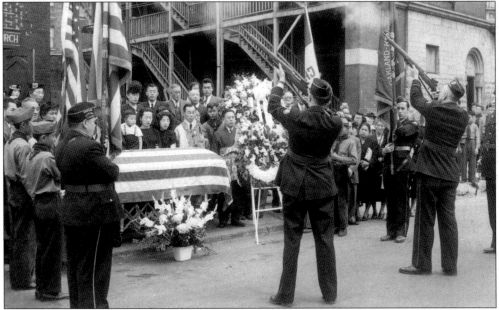

The first Japanese American Military funeral in Chicago. (Courtesy of Kubose Family.)

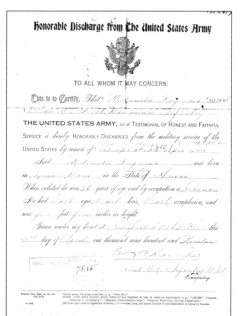

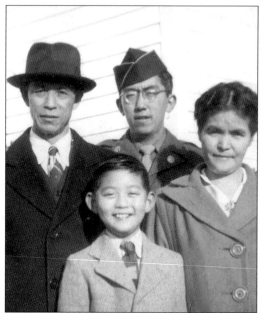

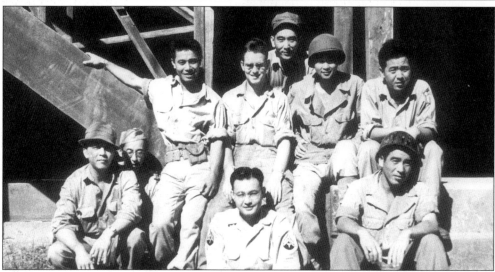

Top Left: Matsuchi Koyama, #3557414, enlisted for World War I and received an Honorable Discharge from the U.S. Army on April 5, 1919. Non citizens who served in the U.S. Armed Forces in World War I or II between September 1, 1939, and December 31, 1946, became eligible for citizenship in 1948 with the residency requirement eliminated.

Top Right: Ted Mizuno with his parents and brother before he left for military service in Japan where he interviewed Japanese soldiers repatriated from Russian prisons in Siberia as part of his MIS duties. (Courtesy of Ted Mizuno.)

Bottom: Ken Mazawa was part of this G-2 Nisei Group, 3-11-45 under Captain Lloyd's command when they fought in Bhamo Burma. This group also included Kazuo Komoto who earned a Purple Heart for bravery. (Photograph by Ken Mazawa.)

The four Oda brothers were together in Chicago before they parted on separate assignments. Peter and Ken Oda were drafted and brothers Dick and Ted volunteered from Granada. Ken was proud to be part of the unique combat 442 team and the other three served in the Military Intelligence Service (MIS).

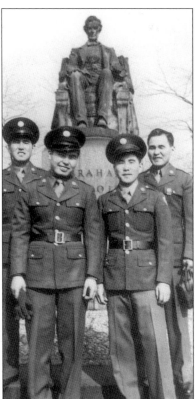

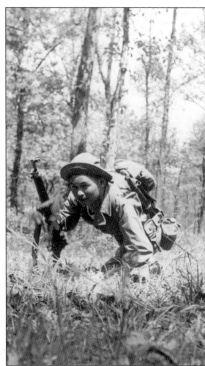

Peter Oda training at Camp Robinson Arkansas.

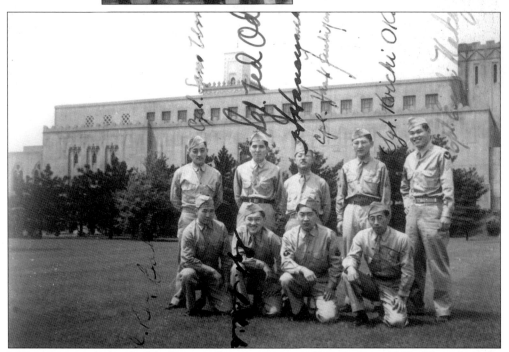

MIS group assigned to India after completing training at Harrisburg in 1943. (Photograph by Ken Mazawa.)

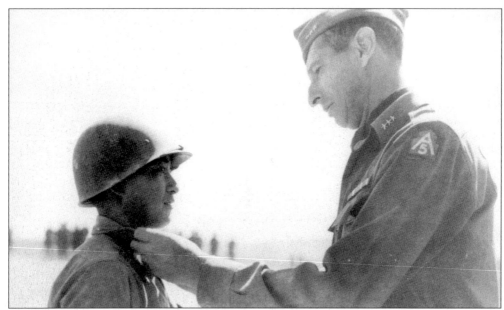

The battlefield promotion of Masami Sam Yoshinari to Second Lieutenant of the 442nd Infantry Regiment by Lt. General Mark W. Clark of the Fifth Army is seen here in San Gimignamo, Italy, on September 4, 1944. (Courtesy of Sam Yoshinari.)

Dick Oda was part of the G-2 General Staff in Alaska, 1945. He and his brother, Ted, both volunteered from Camp Granada and were together for MIS training in Minnesota. Then, Dick was chosen to go to Alaska and Ted went to Pittsburgh to attend the U.S. Air Force Intelligence Academy. More than 6,000 Nisei received MIS training to fight in World War II. (Courtesy of Chiyoko Oda.)

Right: Max Joiichi and friend in Chicago on leave. (Courtesy of Jean Endo.)

Bottom Left: Tak Hirai volunteered for military service in 1943 from Minidoka even though his family was interned from Seattle. Hirai served with the 442nd in Italy and France. (Courtesy of Kazue Mayahara.)

Bottom Right: In the Burma/India theater of war, guerrillas were fought on the Chinese border in support of Chiang Kai Shek. Then, the troops were transported to India on the *Washington*—the largest passenger ship captured during World War I from Germany. (Courtesy of Ted Oda.)

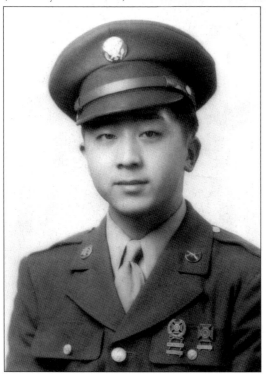

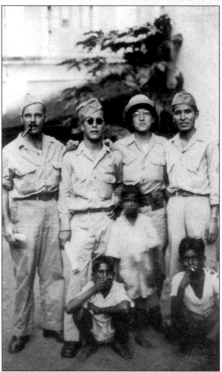

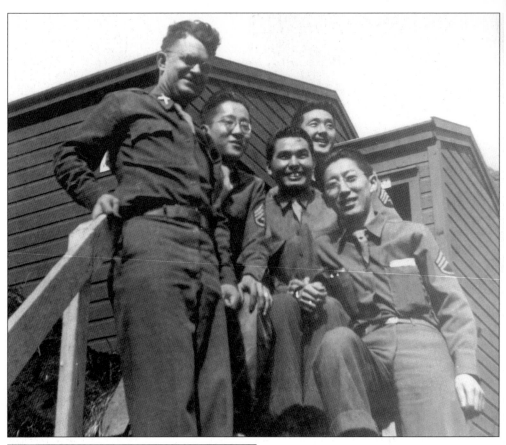

^{81st CONGRESS}
^{2d Session}
H. R. 8153

IN THE HOUSE OF REPRESENTATIVES

April 21, 1950

Mr. DOYLE introduced the following bill; which was referred to the Committee on the Judiciary

A BILL

For the relief of Chiyoko Akashi.

1 *Be it enacted by the Senate and House of Representa-*
2 *tives of the United States of America in Congress assembled,*
3 That the provisions of section 13 (c) of the Immigration
4 Act of 1924, as amended, relating to the exclusion of aliens
5 inadmissible because of race, shall not hereafter apply to
6 Chiyoko Akashi, the Japanese fiancée of Mr. Dick Oda, a
7 citizen of the United States and a veteran of World War II,
8 and that said Chiyoko Akashi may be eligible for a non-
9 quota immigration visa if she is found otherwise admissible
10 under the immigration laws: *Provided,* That the adminis-
11 trative authorities find that marriage between the above-
12 named parties occurred within three months immediately
13 succeeding the enactment date of this Act.

MIS Military men at Adak, Alaska, in 1944. They helped Americans win their first victory in the Pacific with the recapturing of Attu. (Courtesy of Chiyoko Oda.)

Rikiho Dick Oda found it necessary to have a private bill passed through Congress before he could marry Chiyoko Akashi because Americans were not permitted to wed Japanese. His future bride was a graduate of Tsuda University and worked as a translator in the same building as he did. He received assistance from Dr. and Ms. Gilken, his employers while he was a school boy. Their friend, Senator Nolan, introduced a private bill which was passed in Congress. On August 19, 1950, the Soldier Bride Bill was enacted which permitted a limited number of spouses and unmarried minor children of soldiers and veterans to enter America on a non quota basis. (Courtesy of Chiyoko Oda.)

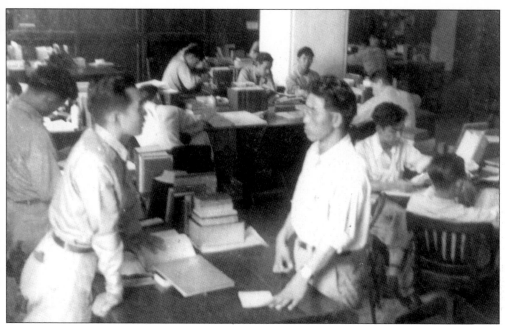

MIS Letter Section in Tokyo, August 1946. (Courtesy of Chiyoko Oda.)

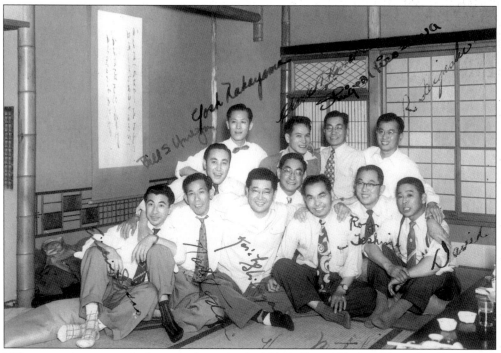

Military servicemen worked as translators in the Nihon Yusen Kaisha during the Occupation of Japan and partied at Komachien Inn, an establishment built for military staff because they were not permitted to frequent geisha houses. Komachien was a high ranking girl in the 11th century, famous for her beauty. The photo was taken May 14, 1954. (Courtesy of Chiyoko Oda.)

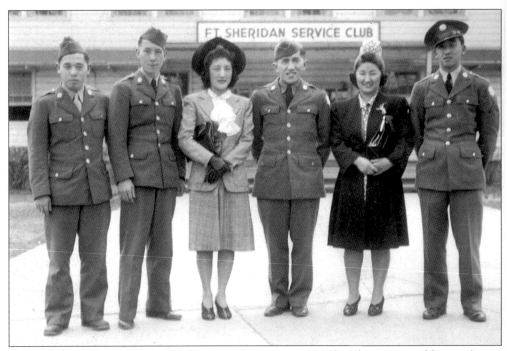

Sister-in-laws Miye and Helen Mukoyama often went to Ft. Sheridan to extend hospitality to Japanese-American soldiers on leave. (Courtesy of James Mukoyama.)

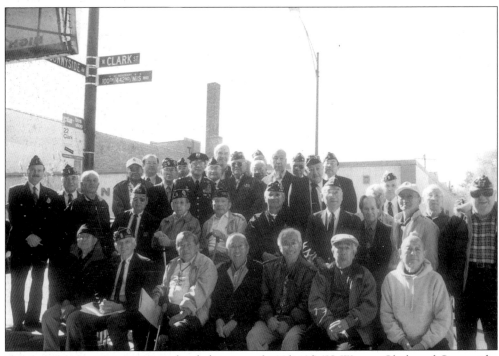

Members of Nisei Post 1183 at the dedication of 100/442/MIS Way at Clark and Sunnyside, October 2001. (Photograph by Alice Murata.)

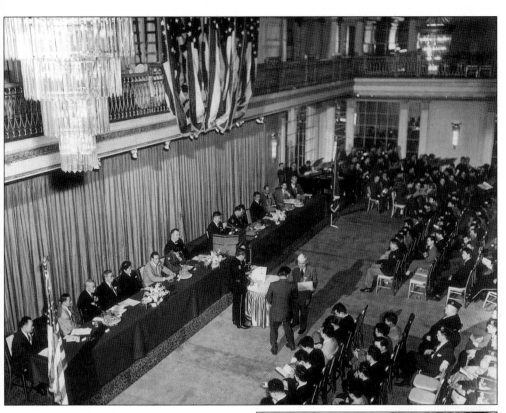

Pictured here is a testimonial dinner honoring Korean veterans at the Stevens Hotel in 1950 with special guest, Congressional Medal of Honor winner Hiroshi Hershey Miyamura—a 442 veteran who served in Italy and was recalled for service in the Korean War. Also pictured is Theophane Walsh, a Marynoll priest, who worked in Los Angeles prior to the war and went to Manzanar. In Chicago, he established a Nisei Center at the Catholic Youth Organization (CYO) in 1944 and permitted Japanese Americans of all religious backgrounds to use space for meetings and activities. (Photograph by Ken Mazawa.)

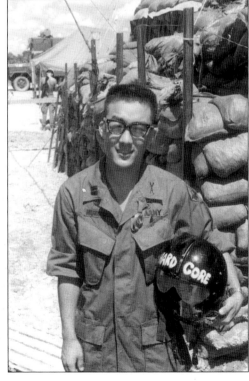

General James Mukoyama in the Mekong Delta, Vietnam, in May 1969. He served as a Battalion S-3 Operations officer for the 4th Battalion, 39th Infantry of the 9th Infantry Division. In 1991 his Army reserve unit was mobilized and positioned in Operation Desert Storm. (Courtesy of James Mukoyama.)

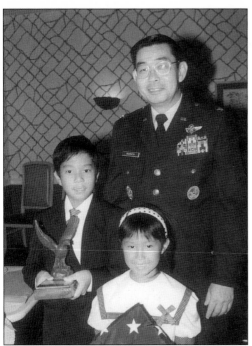

Colonel Ned Murata with his children, William and Michelle, in the Pentagon. Trained as an Electronic Warfare Officer, he flew electronic reconnaissance missions, analyzed intelligence information of the Soviet Union and Asian Communist countries, served in planning and political-military affairs assignments, and served as Base Commander of an air force base in England. (Photograph by Alice Murata.)

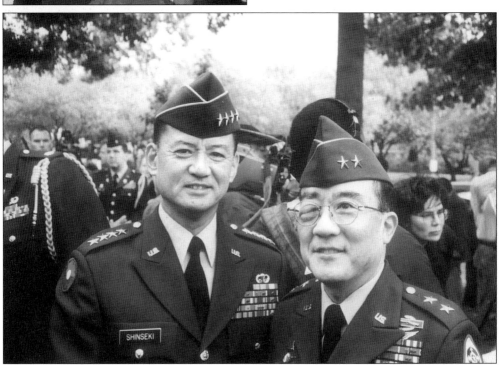

General James Mukoyama and General Eric Shinseki, Army Chief of Staff, attended the groundbreaking ceremony for the National Japanese Monument in Washington D.C. Mukoyama, in partnership with Mas Funai and Shiro Shiraga, led the Midwest region in raising $2.8 million from 2,300 donors toward the $8.6 million necessary to erect the monument. (Courtesy of James Mukoyama.)

Four
FAMILY

For Japanese Americans, family means safety, acceptance, love, and support. Home was stable and predictable, a refuge from the racism which existed in the larger world. Each family member is special and treasured. The Issei considered the family name important and encouraged their children to do things well and not bring shame to the family. Values stressed were honesty, kindness, and respect for everyone and everything. *Shigata ga ni* or helplessness was endured to injustices suffered which were faced with *gaman* or perseverance. Education was encouraged. Competition was discouraged so that in races each child received the same prize at the finish line because each ran the best she/he could.

Family gatherings include extended family members and friends. Delicious food is plentiful and activities fun. Celebrated is the cycle of life—birth, birthdays, graduations, marriages, and anniversaries. Special birthdays include the Kanreki or the 60th birthday when a person completes a life cycle and begins a second childhood. Additional important birthdays are the 77, 88, 99, and 100. Kenichi Morimitsu lived to be 111 years old. Gratitude and respect is given to those that lived before us annually at Obon when their souls return to visit.

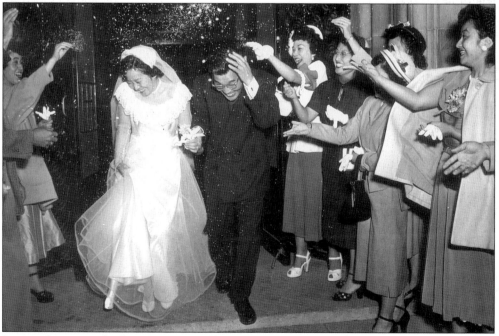

Rice is thrown at the happy couple, Chris Natsuhori and Paul Otake, as they leave the Ray Graham Chapel at the University of Chicago after taking their marriage vows in 1951. (Courtesy of Natsuhori/Otake Families.)

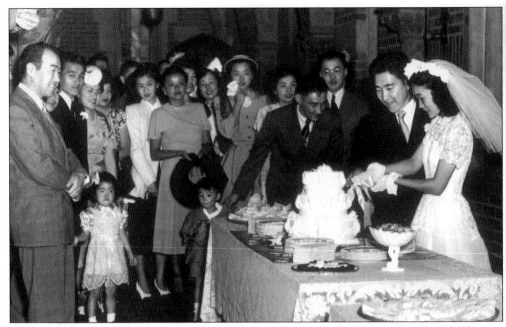

Fukuyo Sakamoto and Jack Hamahashi were wed in 1948 at the Graham Taylor Chapel. This was a popular place for Niseis without any church affiliation to get married. The set price included the cake and reception. From 1944 to 1949 there were 300 weddings and 800 babies in the Chicago area. (Courtesy of Tom Mayahara.)

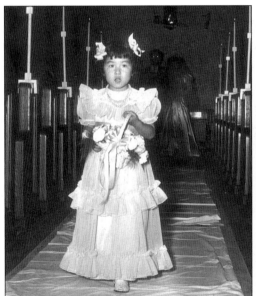

Below: The Chizu Kadota and Dick Nishimoto wedding, January 4, 1946. (Courtesy of Alyce and Rocky Yamanaka.)

Above: Arlene Junko Murata was a flower girl at her aunt's (Margaret Kimiko Takamiya's) October 1949 wedding at the Armitage Japanese Methodist Church. Arlene liked all the pretty dresses her mother made for her, especially this one.

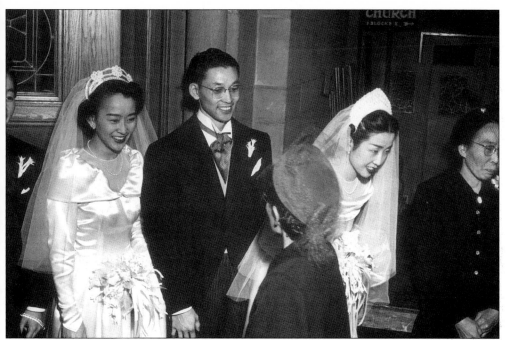

Sisters Haruko and Tomiko Uyeda at their double wedding in December 1950 had more than 600 guests attend their happy event. They were Japanese dance instructors and their students performed at many Chicago events and went on television for the first time in 1949 from the Congress Hotel. (Photograph by Ken Mazawa.)

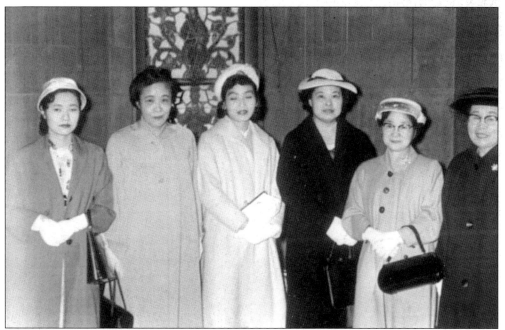

Guests (left to right) Sadoko Nagata, Ms. Fukuya, Mitsu Akitomo, Hanako Murata, Yaye Mayeda, and Ms. Sakamoto attended the Kadowaki wedding together in 1955. (Courtesy of Hanako Murata.)

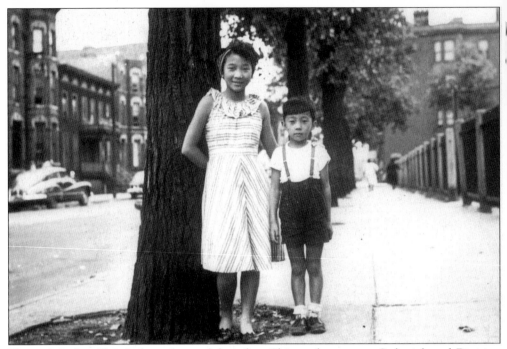

Elsa and Arthur Higashide in front of their first Chicago home near Sedgwick and Division Streets in 1949. The Seiichi Higashide family, originally departed from Peru and interned in Crystal City, arrived in Chicago in February 1949, from Seabrook Farms, New Jersey. It was snowing and the record shop across from their building was blasting "Do the Huckle Buck." The apartment was so filthy Elsa remembers scrubbing the bathroom nearly all night with her mother. (Courtesy of Elsa Higashide.)

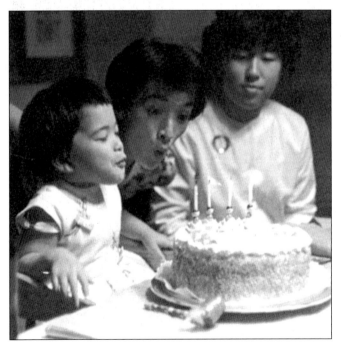

Birthday parties mean family celebrations for the Inouyes. Tomi and Anne enjoy Mariye's third birthday cake. (Courtesy of Tomi Inouye.)

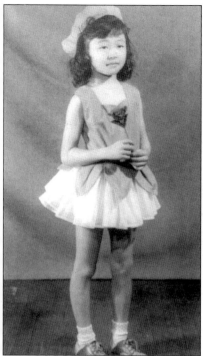

Above: Kita's high school graduation in 1946. (Photograph by Ken Mazawa.)

Left: Momoko Iko dressed for Halloween 1948. She is best known as author of *The Gold Watch*

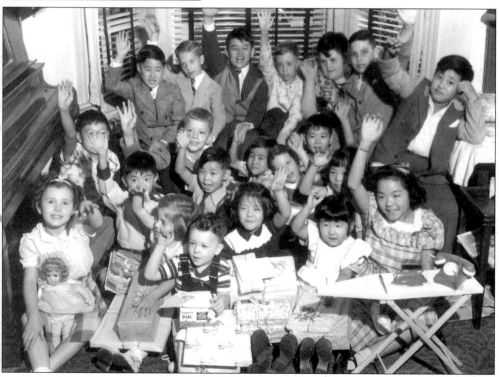

A children's birthday party in the middle 1940s. Integration was rapid in Chicago, unlike in the isolated camps and communities on the west coast. Japanese-American and Caucasian children attended school and parties together. (Courtesy Murata Family.)

57

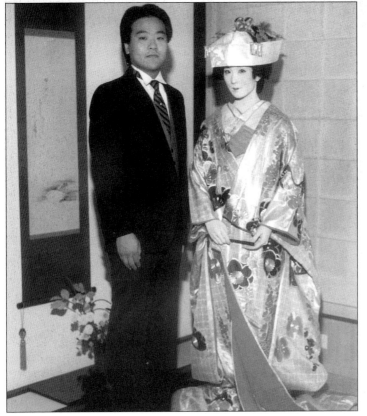

Top Left: Mr Morimitsu lived to be 111 years old and is believed to be the longest living Japanese American in the United States. (Courtesy of Chicago Shimpo.)

Top Right: Fiftieth Wedding anniversary photo of Hatsuno and Hataichi Takano taken in 1972. Her passport picture is featured on page 28. (Courtesy of Jean Mishima.)

Left: For her wedding to George Kawasaki on September 1985, Jane Mizuno wore a Japanese wedding gown in addition to the traditional dress. (Courtesy of Itsuko and Ted Mizuno.)

Quints Juli, Ben, Kristi, Jami, and Kari with their older sister Erin are a joy for the entire community as well as for the Chikaraishi family. Their father and paternal grandfather are Optometrists. (Courtesy of Chicago Shimpo Newspaper.)

This Christmas 2000 card shows the quints, Julie, Karin, Kristi, Ben, and Jami, with older sister Erin. They are wearing sweatshirts indicating where they attend college. For Japanese-American families, education is valued and young people are strongly encouraged to attend universities. (Courtesy of Ben Chikaraishi.)

Celebrating the birth of precious Dana Matsuo, a fifth-generation Japanese American in 1980 are, first row from left, Hatsu Matsunaga (great maternal grandmother), Jan (mother) holding Dana, and Hatsuno Takano (great, great, grandmother). In the second row from left are Jean Mishima (grandmother), Doris Fujii (great-grandmother), and Steve (father). (Courtesy of Jean Mishima.)

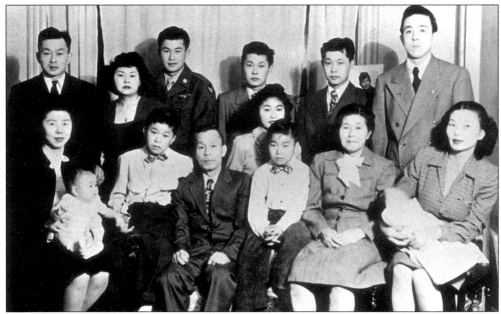

The Kadota Family got together at their parent's home at 2222 Sedgwick in March 1947. Dad was a lawyer in Japan and a successful strawberry farmer on leased land in Atascadero prior to camp. (Courtesy of Alyce and Rocky Yamanaka.)

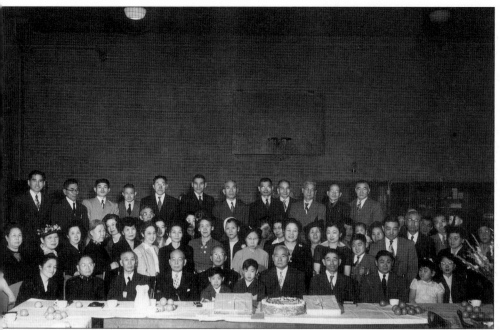

Birthday party for Mr. Ito given by family and friends in 1947. (Courtesy of Ted Oda.)

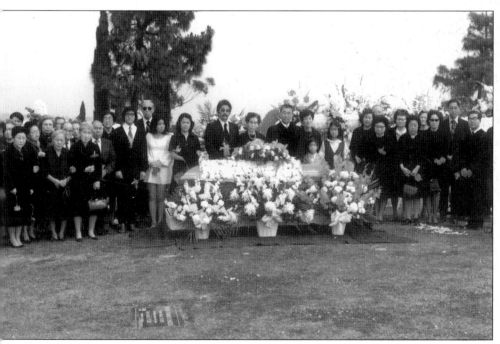

Friends and family gather for a funeral.

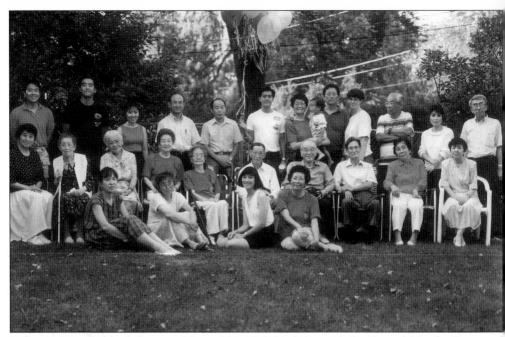

In June 1992, Kashiro Mizuno celebrated his 99th birthday with family and friends. He passed away on Easter Sunday 1995 at the age of 102. (Photograph by Ted Mizuno.)

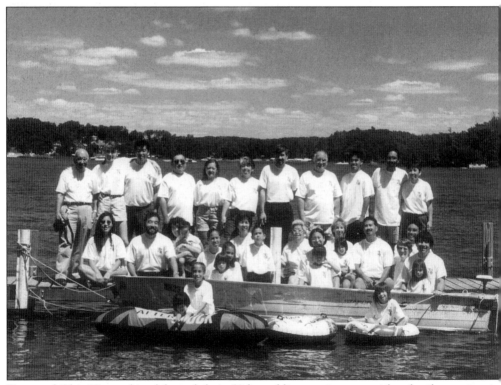

Yone and Chic Tsurusaki celebrated their 50th wedding anniversary with a family reunion in Ranier, Minnesota, in 1998.

Five

SPIRITUAL LIFE

Religion provided comfort through troublesome times. Spirits were uplifted as concerns are shared with others in the process of practicing faith. Until Pearl Harbor, Christian church services were held, but then all Japanese-Americans meetings were forbidden including assembling for Mr. Urutani and Rev. Ai Chi Sai's religious group.

The United Christian Ministry to Evacuees formed in 1942 decided all Japanese Americans should worship together in a non-denominational setting without forming separate Japanese congregations or holding services in the Japanese language. Japanese Americans were permitted use of the University of Chicago Thorndike Hilton Chapel in 1942 but they wanted a more central location. Eventually, the Fourth Presbyterian Church agreed to let them hold separate non-denominational services. Rev. Chiaki Kuzuhara objected to not being able to form his own church and the prevention of giving worshippers choice. Then, many denominations established such as the Congregational, Methodist, and Presbyterian groups. In the early 1940s Buddhism was introduced for the first time in Chicago. Acceptance of what mainstream considered a "barbaric" religion was difficult. Still, the Buddhist groups persisted and exist today with worshipers from diverse ethnic backgrounds..

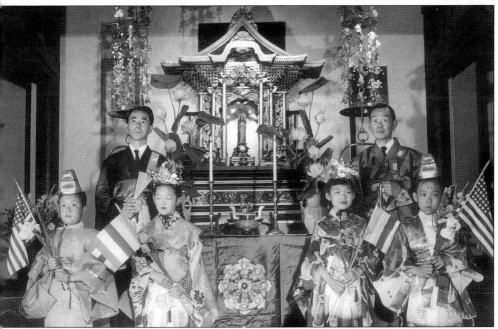

Pictured from left are Ray Horita, Joyce Kubose, Jane Kanemoto, and Perry Miyake dressed as Chigos with Revs. Saito and Kubose in 1954. Chigos were children who followed the Buddha in a festive procession as he traveled. (Courtesy of Kubose Family.)

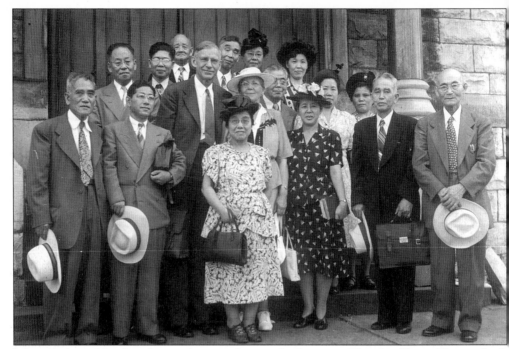

Ichiro Endo and his friends were lay preachers in the Japanese Church of Jesus Christ, which was also known as Elm La Salle Church. Endo came to America at the age of 16 to build railroads. At 30 he took a picture bride and they moved to Chicago in 1922, when offered a chef's job. This church eventually purchased their own church building on Devon Avenue. (Courtesy of Jean Endo.)

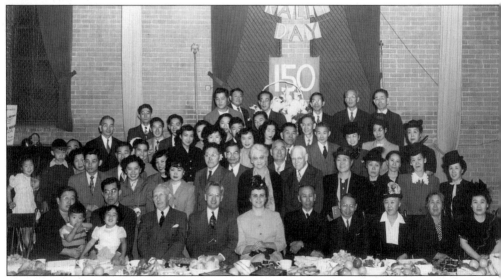

First Anniversary of the Armitage Japanese Methodist Church on October 3, 1948. In May 1942, St. Paul Methodist Church sponsored four Japanese Americans to live in their parsonage. They held a Christmas Party for 50 Nisei that year. By spring 1943, 250 Nisei attended a meeting at that church. (Courtesy of Ted Oda.)

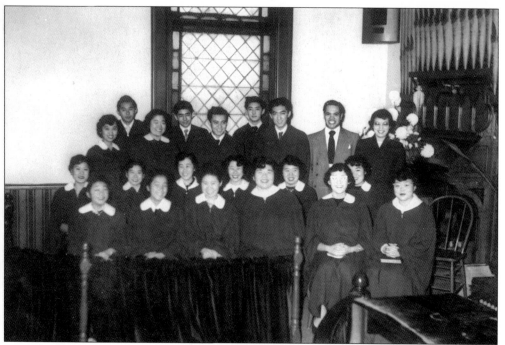

Lakeside Church choir. (Photograph by Ted Mizuno.)

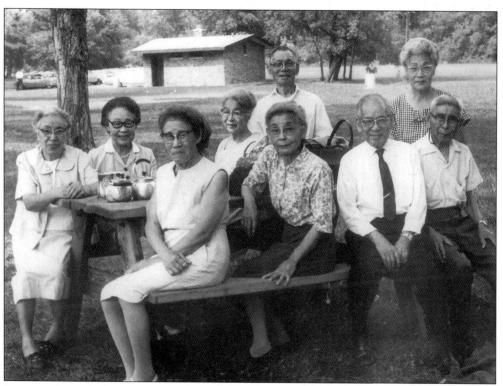

Issei members of Christ Church of Chicago at their annual picnic on July 3, 1949, at Illinois State Beach.

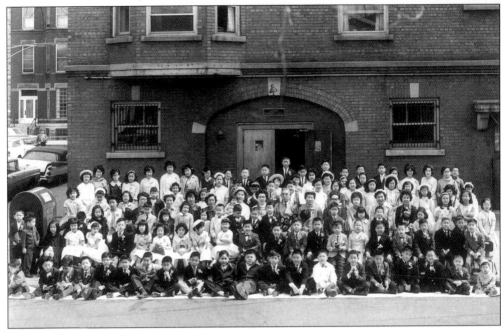

Dharma School children in April 1963, in front of the Midwest Buddhist Church located at North Park and Menominee Streets. (Photograph by Fred Yamaguchi; courtesy of Yae and Bill Adachi.)

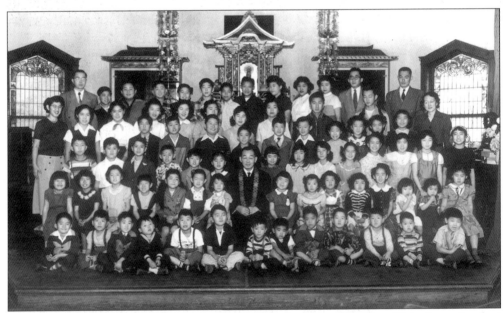

Buddhist Church of Chicago Dharma school children in front of the altar. This picture is taken in front of altar made by the Nishura brothers, who come from a family that were altar builders for generations. It was used in Heart Mountain for services until this camp closed and was then given to Rev. Gyomay Kubose who used it as the main altar for many years. It is now being used in the Nokutsudo or columbarium room of Buddhist Temple of Chicago. (Courtesy of Kubose Family.)

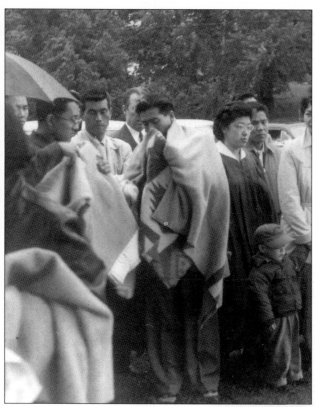

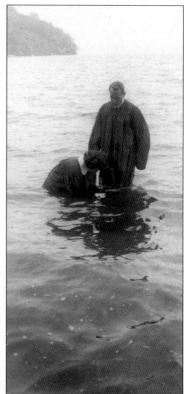

Top Left: Witnesses to the baptismal. (Courtesy of Itsuko and Ted Mizuno.)

Top Right: Betty Shimabukuro's baptismal in Lake Michigan was done by Rev. Johnson of Lakeside Church. Her sister was also among those baptized as church members witnessed the event. (Courtesy of Itsuko and Ted Mizuno.)

Bottom Right: Lakeside Church Sunday School children. (Photograph by Ted Mizuno.)

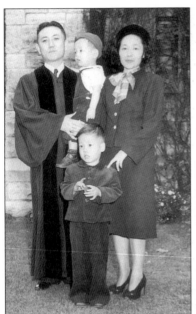

Left: Rev. Jitsuo Morikawa with his wife, Hazel, and sons Andrew and Dennis, both born in Chicago. When he was unanimously voted to be head pastor of the 119-year-old First Baptist Church in 1948, he became the first Nisei to head a predominantly white congregation in America. In 1943, after he left Poston Camp, he took the position of Associate Pastor and when the minister left for another assignment he became the head minister. (Photograph by Ken Mazawa.)

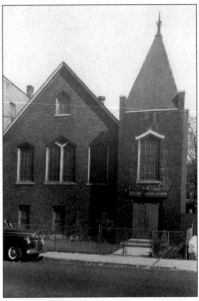

Left: The Buddhist Church at 5487 S. Dorchester was purchased by Rev. Gyomay Kubose in 1944 to teach American Buddhism, a previously unknown religion to Chicagoans. In 1956 they purchased the Leland Avenue property from Goldblatts. (Courtesy of Kubose Family.)

Bottom: Issei members with their minister, Rev. Kuzuhara, in front of the Lakeside Church altar. This group met at the Yoshida home and then the Moody Bible Institute before 1950 when they purchased this German church on Wellington. (Photograph by Ted Mizuno.)

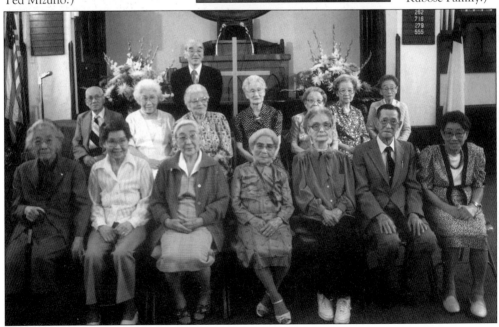

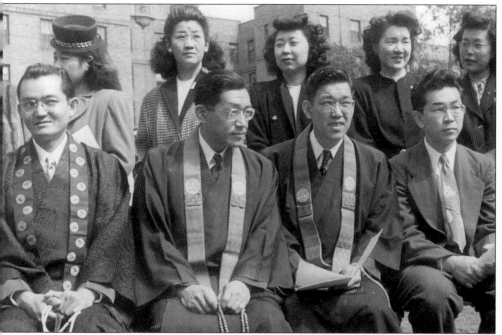

Visiting ministers and guests at the first Eastern Young Buddhist League Conference at the Midwest Buddhist Church in 1946. (Photograph by Bill Adachi.)

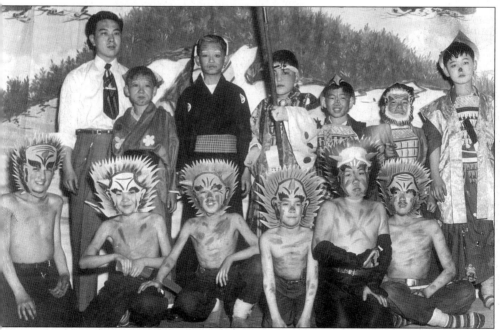

As part of Wesak Festival or *Hanamatsuri* which means Flower Festival, a Dharma School Play of Momotaro is directed by teacher Yosh Fujitani. Also pictured, from left, are students Bobby Doi, Don Koizumi, Suzuki, Kaz Ideno, and Hiko Hattori. This story of Peach Boy is utilized to perpetuate cultural values deemed important, including kindness, generosity, sacrifice, and friendship. (Courtesy of Kubose Family.)

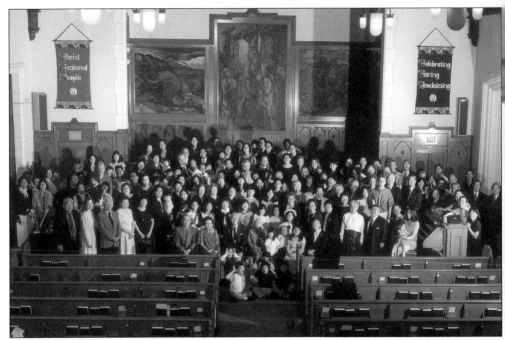

Church of Christ, Presbyterian, on Spaulding Avenue existed prior to WWII with Rev. Ai Chi Tsai and Moody Bible students leading worship. (Courtesy of Jean Mishima.)

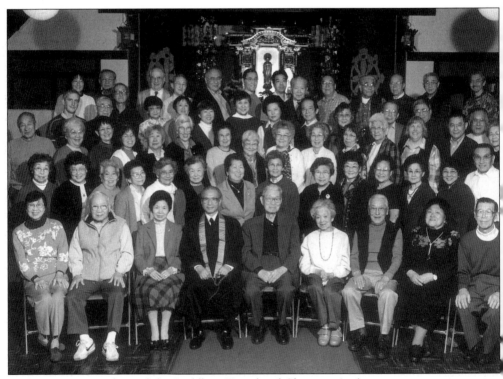

Asoka Society members of the Buddhist Temple of Chicago. Asoka is a service organization established in 1952 to provide support for Temple activities. (Photograph by Donald Nozawa.)

Six

WORK

Chicago was attractive because jobs were plentiful. The city turned its back on the depression by producing high technology and electronic war goods in the forties. There were so many unfilled positions that recruiters went to the camps begging for workers. Japanese Americans were happy to be employed for $55 a week instead of the $19 or $21 a month in camp. They liked being appreciated for their industry.

With huge labor shortages, job restrictions were lifted during the war and Japanese Americans were able for the first time to access many jobs previous closed to them. They secured industrial positions, joined unions, and entered professional positions. It was possible to own small businesses. Japanese Americans operated grocery stores, restaurants, beauty shops, photography shops, and provided a wide variety of services. Hotels and boarding homes serving their own people flourished. Professional practices in medicine, dentistry, optometry, and law thrived. They were eventually able to hold teaching positions and work for the government. Chicago afforded them opportunities for career growth and economic success.

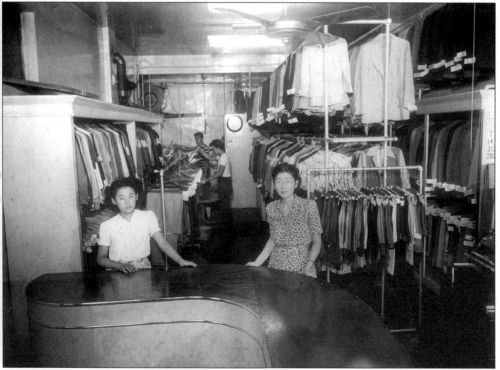

Torazu Hidaka had experience with cleaners in San Francisco. In Chicago by 1948, he established a chain of cleaners in different parts of the city. (Courtesy of Richard Hidaka.)

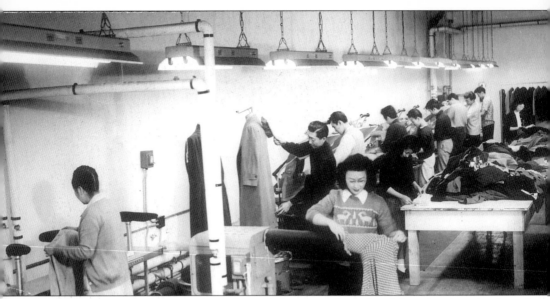

Sun Cleaners was the main plant where clothes were cleaned and then distributed to branches at Savoy, Diana, and Division Cleaners.

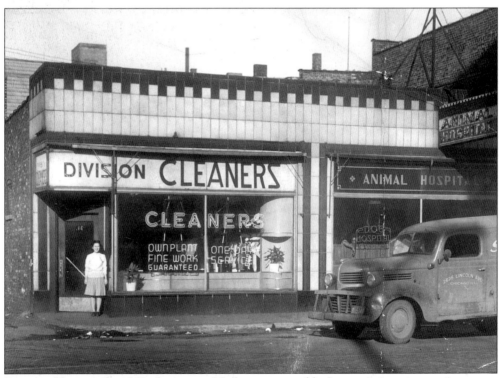

Division Cleaners. By 1960, there were 38 cleaners owned by Japanese Americans.

Top Right: Harry Nakashima, a pedigree breeder, with Taisho, his prize wire terrier, who won 22 trophies in 1952. This dog is considered best of the breed. Harry ran Showyre Kennels with assistance from his wife Helen at the same time he held a chick sexor position. (Photograph by Ken Mazawa.)

Bottom Left: Diamond Grocery store on Clark Street near Division. (Courtesy of JACL.)

Bottom Right: Nisei could find work as a butcher since union jobs were opened to Japanese Americans in Chicago. (Courtesy of JACL.)

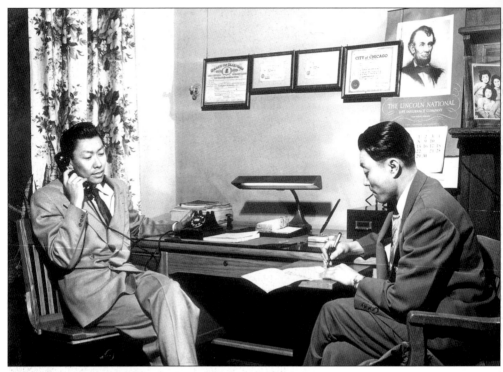

The Seno brothers, Tom and Sam, operated a real estate office. During and after the war the city faced housing shortages and many would not rent to Japanese Americans, who were forced to live in WRA designated areas which served as a buffer between the city's Caucasian and black residents. By 1945 Japanese Americans operated more than a hundred apartment buildings, boarding houses, and hotels serving mainly Japanese Americans. (Photograph by Ken Mazawa.)

This building at 4200 Berkeley was purchased by Ted Oda after he returned from military service. In addition to the Clark and Division area, many Japanese Americans resided in the Woodlawn and Kenmore-Oakenwald areas. (Courtesy of Ted Oda.)

Among the girls affectionately known as the "Girls of La Salle Mansion" are: (first row) Aiko Haga, Marty Sugimoto, and Rule Kaneko; (back row) Sue Okubo, Nori Yamagiwa, Margaret Morita, and Sachi Sugimoto. They came to socialize with the many single bachelor men who resided in the La Salle Mansion Annex. (Courtesy of Tom Mayahara.)

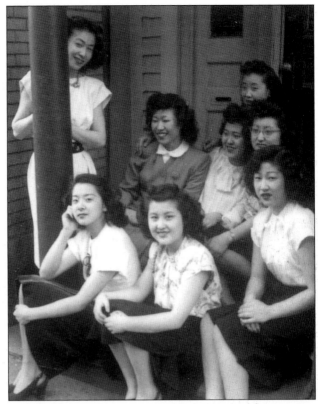

The La Salle Mansion and Annex located at La Salle and Maple Streets was leased by Hiroshi Kaneko in 1944. Kaneko had difficulty finding a place to live so he purchased this 160 unit place to rent to Japanese Americans arriving from camp. His family also purchased a 40 acre farm in Argos, Indiana, to grow Japanese vegetables, which they sold in a family grocery story. (Courtesy of Hiroshi Kaneko.)

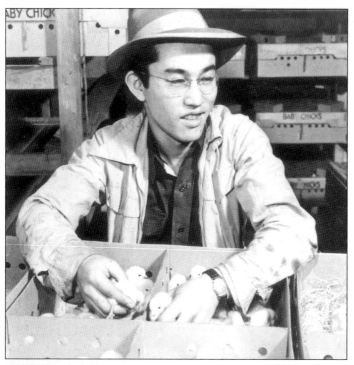

A way to determine the sex of baby chickens was discovered by Japanese Americans and several schools were established. Chick Sexing was taught at the National Chick Sexing Association located at 821 La Salle Street and at the American Chick Sexing School in Nokomis. Females were preserved and the male chicks destroyed. (Courtesy of JACL.)

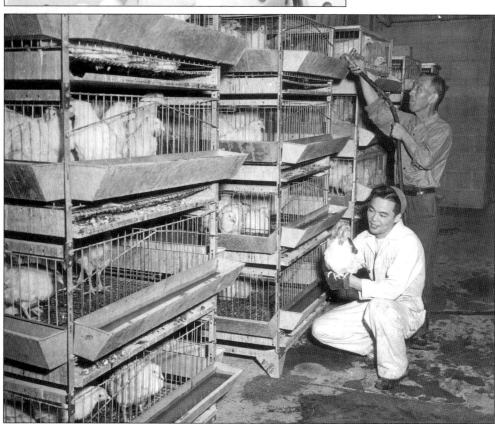

Dr. Newton Uyesugi Wesley, formerly of Oregon, began his optometry practice in 1936. He had a serious eye ailment, bilateral kerato corneas, which he corrected by developing contact lenses that did not distort the eyes. He holds a patent for this discovery and made use of contact lenses popular. (Courtesy of JACL.)

Shig Wakamatsu did his share for the war effort as a chemist for the Lever Brothers Company that hired him in 1943. In addition to keeping the troops clean, he helped get nitrate glycerin into explosives and produced essential parts of medications. Wakamatsu is also well known for his life-long commitment to erasing racism. (Courtesy of JACL.)

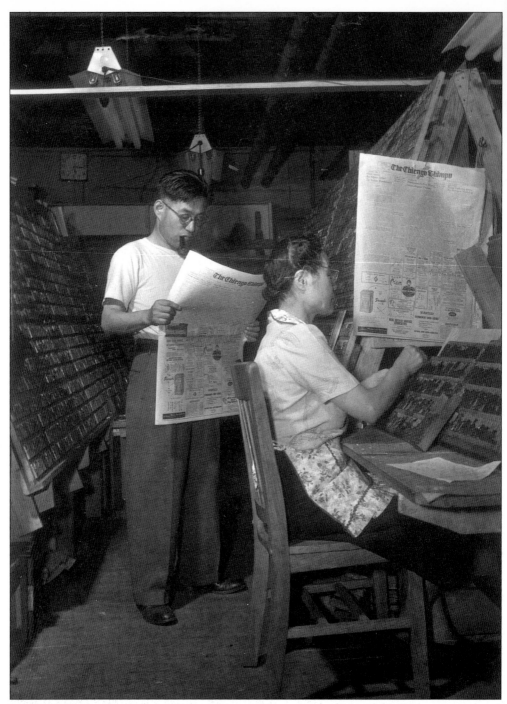

Ryochi Fuji, the first editor of the *Chicago Shimpo*, at work in 1946. This paper started publishing on November 15, 1945, in the Japanese language and on May 1, 1947, the first English section appeared. The paper continues to be published today. (Photograph by Ken Mazawa.)

Top Right: The premiere issue of *Nisei Vue* was published on April 24, 1948, by Art Hayashi. It features a Chicago girl, Nori Okamura, photographed by Ken Mazawa. (Courtesy of Ken Mazawa.)

Bottom Left: The 1949 Chicago *Japanese American Yearbook* cover was designed by Masato Kumano, a noted muralist from Los Angeles. The yearbook was published by the Kalifornians, with Joe T. Komaki as editor. (Courtesy of Merle Kaneko.)

Bottom Right: Cover of *Scene Magazine* with Ken Mazawa's photo of Sen Hanamoto carrying her granddaughter. Hanamoto came to America in 1909 and relocated to Chicago after internment in California. Mazawa worked as a camera man for Coronet Studios and has won many photographic awards. (Courtesy of Ken Mazawa.)

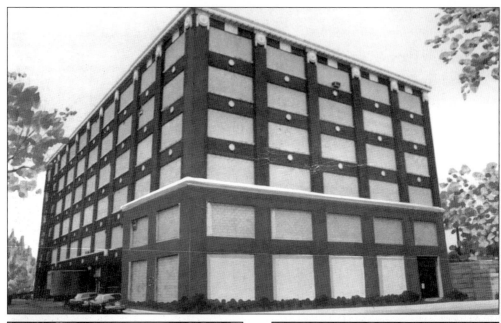

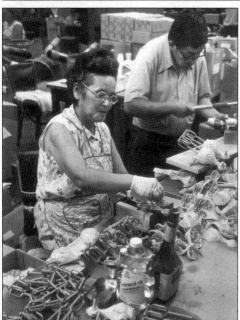

Top: The General Mailing Company was established in 1944 by Alan Hagio, James Nishimura, and Ted Uchimoto, as an offshoot of Cuneo Press. As many as 600 workers did piece work as a first job after leaving camp, and then left as better positions became available to them. GMC was moved to Washington Street in 1962 from Indiana Avenue. (Courtesy of Mitsu and Ted Uchimoto.)

Bottom Left: Kiyono Ozaki working at the JASC Senior Workshop in 1970.

Bottom Right: General Mailing worker doing the highly skilled task of separating pages of a national magazine. (Courtesy of CJAHS, Strength and Diversity Collection.)

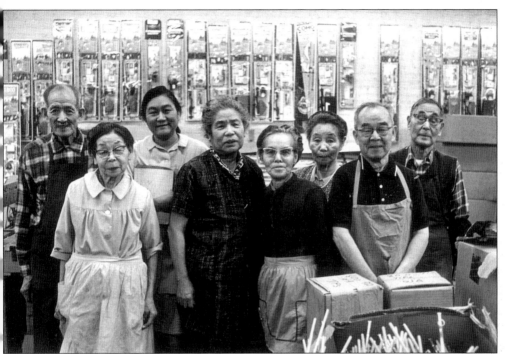

Workers at the JASC Senior Citizens Work Center in 1971. This center was established in 1962 and at its height employed more than 150 workers in productive assembly jobs for small sums of money. It closed in 1988. (Photograph by Mary Koga.)

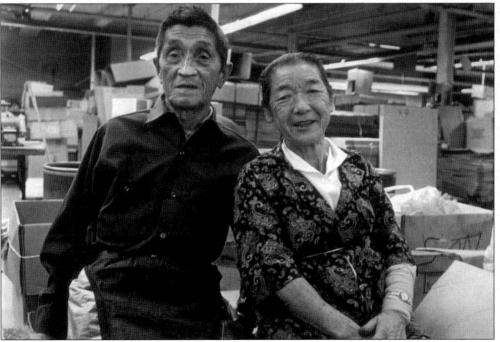

Ruth Lulu Omura and Alyce Kadota at the Oriental Bazaar in the Plumbers Building on October 3, 1949. (Courtesy of Alyce and Rocky Yamanaka.)

Interrogated by the FBI three times after America declared war on Japan, Kashiro Mizuno lost all properties from his 21 years of work between 1921 to 1942 when he was sent to Tule Lake and then Topaz. After the war, he worked in Arlington Heights but thought he would never be able to own a home there, so decided to go into business for himself and purchased an apartment building at 1110 West Belden. (Photograph by Ted Mizuno.)

Mizuno purchased the delicatessen on the corner of Seminary and Belden when the owners retired, even though he did not know how to run the business. His wife and two daughters made a success out of this venture. (Photograph by Ted Mizuno.)

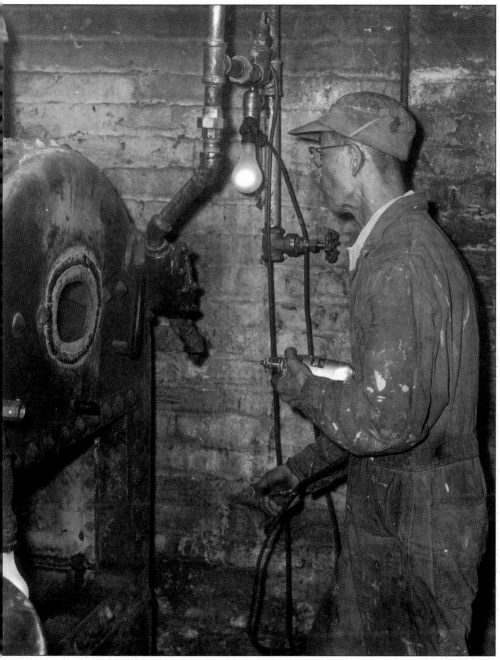

Kashiro Mizuno learned how to hang wallpaper, paint ceilings, and do plumbing. He invented a conveyer system to move coal for heating and hot water. He eventually sold this building to De Paul University. (Photograph by Ted Mizuno.)

Mary Miyashita and Seeshu Shintani assisted voters on Election Day at the Hampton Court Apartments, owned by the Miyashitas in 1947. (Photograph by Ken Mazawa.)

Pictured in 1975 are the JASC Board members who initiated many projects such as the Fuji Festival. (Courtesy of Ted Uchimoto.)

Seven
COMMUNITY

A sense of community has always existed among Japanese Americans. Even when few Nikkei lived in Chicago, they gathered for picnics and social events. They provided each other with support and assistance. Taking care of those in need is done cheerfully as they always reach out not only to those of the same ethnic group but to others especially if their civil rights are violated.

Assimilation into the mainstream was always the goal for Japanese Americans when they entered Chicago in the forties. By the time the WRA closed its Chicago office, it became evident that mainstream agencies lacked knowledge of the Japanese language and experience to assist evacuees. The Mutual Aid Society formed in 1934 was unable to handle all the requests received. The Chicago Resettlers Committee then tried to help with housing and employment. Many organizations formed such as the Japanese American Council, the Japanese American Citizens League, Chicago Japanese American Association, and Kenjinkais made up of people from the same prefecture in Japan.

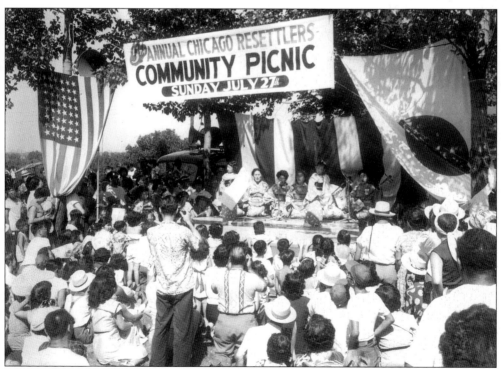

Chicago Resettlers Community Picnic. In the late 1940s, it was not unusual for more than 3,000 people to attend a picnic to socialize, eat, and enjoy the activities.

CLARK AND DIVISION AREA MAP
1945–50

GOETHE ST.

Various Retail Shops
1253 Klaner Funeral
Oishi Apartment
Asato Tofu – original location
Windsor Theater
1219 Windsor Rooming House
1213 Penny Arcade (Street)
Gold Coast Bowling and Pool Hall Above

Surf Theater (Later Playboy)
Restaurant

1201 Dressler Drugs | Obee Barbecue | Ting-a-Lines | Greek Deli | Drs. Office Cleaners

Chinese Restaurant
Night Club

DIVISION ST.

Private Streetcar Co
Later
Lewellen Men's Store
Bedford shirt Shop
Restaurant

Talk of the Town Night Club
Higashi Apartments Above Kato
Rib House (Sam Katz)
1153 Excel Grocers
1151 Tenkatsu Restaurant
Rooming House
Night Club

CLARK ST.

Small Stores
Hikawa Hotel
Taniguchi Restaurant below
York Foods 1250
Sanitary Kaita 1248
New Service Grill Taniguchi 1248
Nisei Tavern 1238
Don Noro Veterans Club 1238
Woolworth
Wah Mai Lo 1222
Yamasaki Rooming 1216
Susumu Hasegawa 1210
Junji Hasegawa, MD 1210

Uptown Players Playhouse

1231 Kochiyama Apts

114 Division Cleaners
*1200 Clark Powder Box

High Rise Apt. Building

White Tower

Hot Dog | Upside Down Sammy | Mark Twain Beauty Shop | Band Box Night Club
Ding Hoe
Frank's Jewelry 1168
Playtime Bar 1158
Oriental Recreation Club 1158
Auto Repair Shop 1158
JA Employment Agency 1148
Amimoto –Optometrist
Marquis Lunch
Band Box Nightclub
Okuhara Hotel 1138
Mivako Japanese Restaurant

LA SALLE ST.

*1200 Clark Building
Chikaraishi Optometrist
Kumamoto – Dentist
Hiura Dentist
Hiura Optometrist
Jiro Yamaguchi, Attorney
Takahashi, Optmetrist

Arakawa Shoe Repair | 149 Sato Tofu
Elm LaSalle Church Japanese Church of Jesus Christ 1136

LaSalle Photo 1034

Kiyohara Cleaners

Ogden School

High Rise

Dearborn Plaza Hotel

Loeber's Auto Service

MAPLE ST.

Loeber's Garage

Olympic Hotel

1019 Villaneuva Custom Tailor Shop

Newberry Library

Washington Park A.K.A. Bug House Square

OAK ST.

CLARK ST.

Rainbow Restaurant 1130
Toguri Merchandise 1128
Liberty Inn (Yamamoto) 1126
Surugaya Sweet Shop 1122
Sun Grocery Store (Yahiro) 1120
Nisei Barber Shop 1118
Miyamoto Jewelry 1118
Sakurada Carpentry 1118
Crystal Hotel Clark Maple

Clark Maple
Auto Service 1038
Ted's Restaurant 1030
Anchor Club Bar 1020
Corregidor Barber Shop
Kaneko Hotel 1020
Kayford Imports 1020
Yamato Café 1018
Gila River Restaurant 1018
Rickett's Restaurant
Diamond Trading 1012

LaSalle Mansion
Mutual Business
1039 Tomihiro

Greek Church

Omi Rooming Nishimura Apts
House Drug Store

Henrotin Hospital

Ikoma Rooming

**1110 LaSalle
CYO Catholic
Youth Organization
Chicago Nisei Sports Assoc
Citywide Recreation
Girls Club Council
Japanese American Council
Midway Golf Association
Nisei Periodicals
Resettlers Office

LA SALLE ST.

A girl on the merry-go-round, the main attraction. The giant carnival in Lincoln Park, which was sponsored by the Chicago Nisei Veterans Club in 1949. (Photograph by Ken Mazawa.)

The Ellis Community Center was established in 1948 by the Christian Evangelical and Reformed Church. Restrictive covenant forces did not want this center within their south side white zone, but Rev. George Nishimoto persisted. The center's mission was to provide religious and social outlets for dislocated Japanese Americans from camps and to assist them with assimilation into the larger community. On June 8, 1949, the Evangelical and Reformed voted to merge with the Congregational Christian churches (Rev. George Aki and Rev. Kiyoshi Ishikawa) and in 1955 acquired Temple Emmanuel at 701 W. Buckingham. Currently they are located on Rockwell Street. (Photograph by Ken Mazawa.)

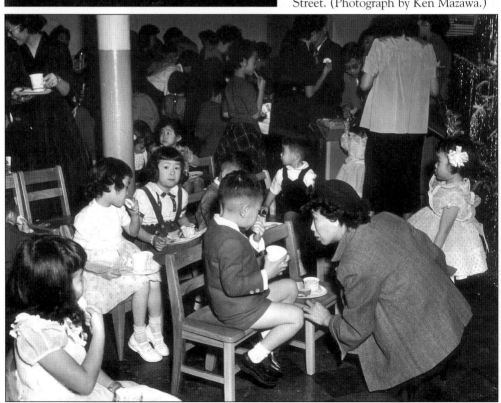

Helen Akita with daughters and their friends going to the movies near Clark and Division. (Photograph by Ken Mazawa.)

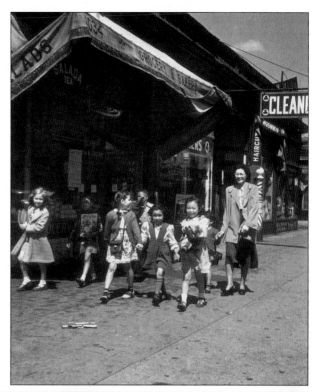

The children of Corky Kawasaki, the first executive director of Chicago Resettlers, enjoy reading books from a Chicago Public Library substation at Ellis Center. Within the first year of operation, the Ellis Community Center became the gathering place for a dozen diversified organizations with weekly attendance over 600 supported by 8 full-time staff members and 21 volunteers. (Photograph by Ken Mazawa.)

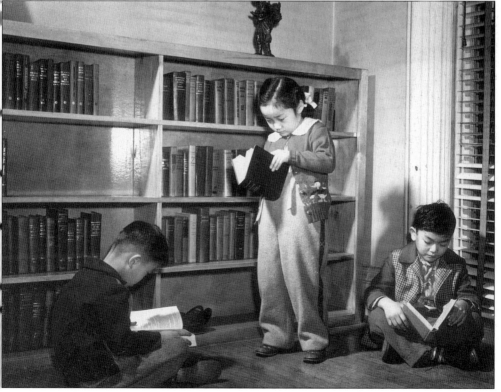

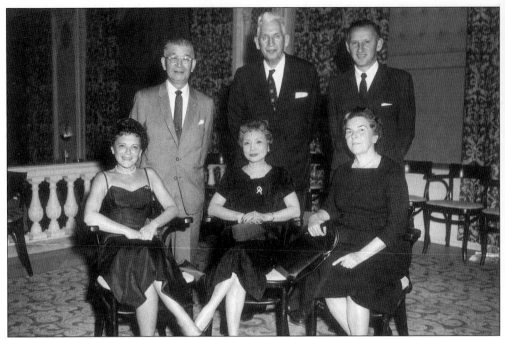

Pictured at the 1950 National JACL Convention in Chicago, from left to right, are the following: (seated) Addie Yates, Mary Yatabe, and Ms. Douglas; (standing) Thomas Yatabe, Paul Douglas, and Sidney Yates. It has always been important to help elect politicians such as Douglas and Yates, who could be counted on to support Japanese-American causes. Thomas Yatabe was the first National President of JACL. (Courtesy of JACL.)

Bill Curtis with JACL members celebrate President Ford's presidential pardon of Iva Toguri in 1977. In 1949 she was found guilty of one of eight acts of treason for broadcasting on Radio Tokyo as Tokyo Rose. She spent eight-and-a-half years in prison and upon release she moved to Chicago to live with her father. Clifford Uyeda started a movement to get her a presidential pardon after learning witnesses were coached by the FBI for two months and lied on the stand. Toguri stated that her father was proud that she had not given up her American citizenship. (Courtesy of JACL.)

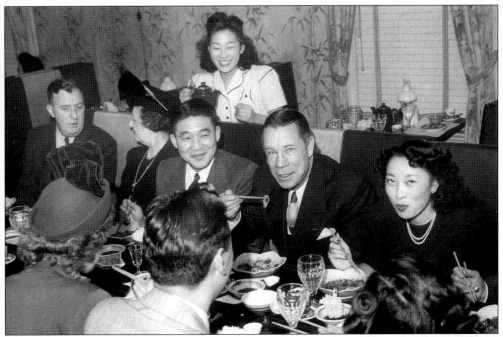

Noby Honda, Joey Brown, and Mari Sabusawa Michener at Wisteria Restaurant. Honda could have listened to Brown all night as he told wonderful stories about the early beginnings of the legitimate theater. In 1946 Chicago hotels did not accommodate blacks, so negotiations were necessary for Brown to attend the JACL Inaugural Ball in 1946. When Sabusawa became Chicago JACL president, she was the first woman to hold that office in the history of the JACL National Organization. She married author James Michener. (Courtesy of JACL.)

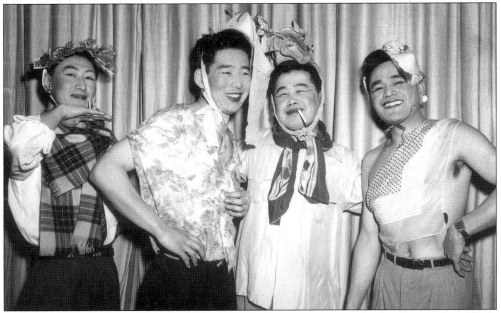

Joe Maruyama, Joe Nakayama, Richard Tani, and Frank Sakamoto dress up to entertain for the 1000 Club Wing Ding in 1953. (Courtesy of JACL.)

The judges for *Scene Magazine*'s Commodore Perry Centennial Photo Contest are Ragner Hendenvall, president of Chicago Area Camera Club Association; Frank Fenner Jr., APSA photograph editor; and Harry K. Shigeta. They chose winners from over 500 entrants in 1953. In 1948 Shigeta won Best Print at the International Photographers Fair in England. According to Tate Yoshida, the Chicago area Camera Club Association held local competitions and the first year Japanese Americans took part in the program they took all the top prizes. "That riled the other camera clubs, [but] you have to consider our guide is a photo salon judge and he coached us." (Photograph by Ken Mazawa.)

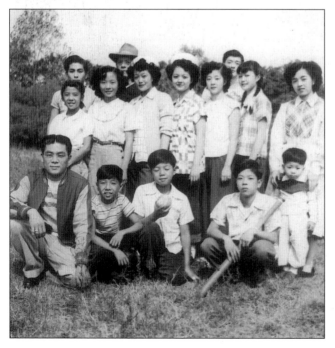

Japanese Peruvians in Chicago. After Mrs. Shibayama and her daughter were jailed in Peru because her husband was not at home, he gave himself up. The police came without warning and arrested people. They sailed to New Orleans and were interned at Crystal City. When the camp closed in 1946 they went to Seabrook, New Jersey, before moving to Chicago. About 2,000 Japanese were rounded up from 12 South American countries and deported at the request of the U.S. government, to be traded for Americans. At the end of the war, 300 Peruvian Japanese fought deportation to Japan and remained in America. (Courtesy of Elsa Higashide.)

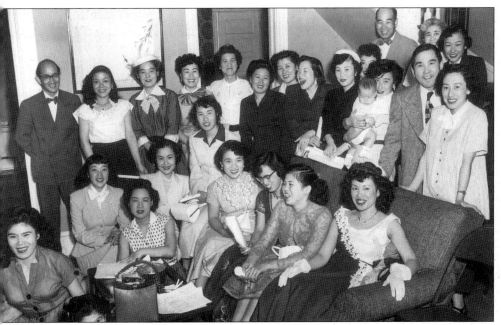

Members of Cosmos, the Japanese War Brides Club of Chicago, arrived with American husbands in the late 1940s and early 1950s. By 1952 this club had 40 members and considered itself to be the largest and most active club in America. The women held bi-monthly meetings on the north side and south side of the city, with socials that included their husbands and children. (Courtesy of JACL.)

The first Christmas Party in America for students from Japan attending Chicago area schools was sponsored by Shinya-kai, a Kibei Club. Most students were on scholarships sponsored by religious groups. Sohaku Ogata, a Zen priest of Shokakuji Temple, was the only non-Christian at the Chicago Theological Seminary in 1950. (Photograph by Ken Mazawa.)

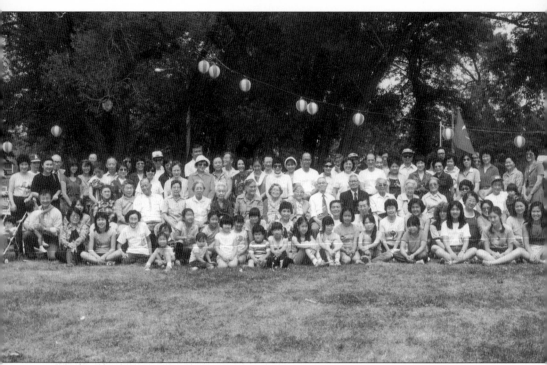

The Hiroshima Kenjinkai Picnic in 1980. Kenjinkais were organizations formed by people from the same Japanese prefecture. (Courtesy of Mitsu and Ted Uchimoto.)

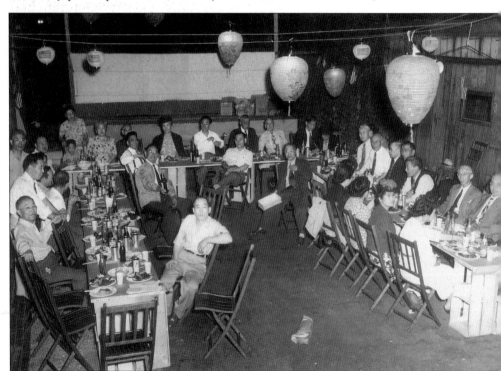

The Yamanashi Kenjinkai Party in August 1947. (Courtesy of James Mukoyama.)

94

Ted Tadashi Uchimoto with the King of the Hiroshima Kenjinkai Picnic in 1986. His father was a successful potato farmer who married a picture bride and had a son, Tadashi, who was born in Stockton in 1918 before the family went to Japan. Educated in Japan, Tadashi returned to America in 1938 at age 19 to work as a schoolboy for a wealthy Jewish family. In camp he worked as a cook and then a buyer who traveled to Chicago to purchase goods. In addition to being an owner of General Mailing, he was well known as the President of Hiroshima Kenjinkai and President of the Japanese American Association of Chicago (JAAC). For many years the JAAC held Japan Festivals at Botanic Garden and selected a father and mother of the year at their annual New Years Party. In cooperation with the city of Chicago they work for world peace by holding annual memorial services for atomic bomb victims. (Courtesy of Mitsu and Ted Uchimoto.)

Kagoshima Kenjinkai Picnic on August 13, 1950. (Courtesy of James Mukoyama.)

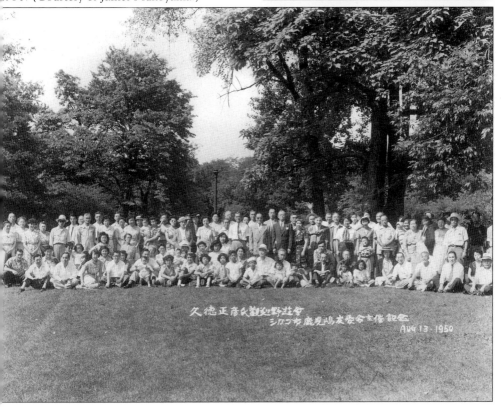

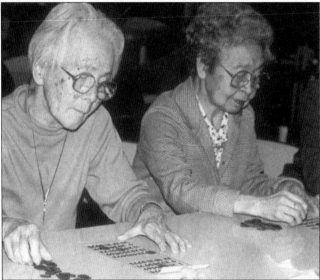

Above: Heiwa residents on an outing. This HUD-subsidized 200 unit building for seniors was completed in 1980 by the Japanese American Service Committee under the directorship of Rev. Masaru Nambu with financial support from the Nikkei community. (Courtesy of Heiwa Terrace.)

Left: Bingo is a popular Heiwa resident activity. (Photograph by Alice Murata.)

Below: Brush Arai and friend entertain at the annual Heiwa Christmas Party. (Photograph by Alice Murata.)

Isseis at the Keiro Nursing Home Opening on April 24, 1993. Approximately $2 million was raised by the Japanese American Service Committee from the community to build this facility, but they were unable to operate it successfully. JASC sold it in June 1995. (Photograph by Ken Mazawa.)

On April 2, 1986, Japan Air Lines made the first non-stop Chicago to Tokyo flight. (Courtesy of *Chicago Shimpo*.)

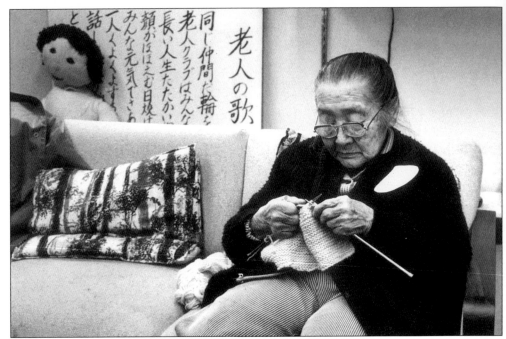

Kawayo Okuno knits at the Adult Day Care Center on October 20, 1987. It was *tanoshi*, or a pleasure for the Issei to make gifts for their children, grandchildren, and friends. It kept their minds and hands working. (Photograph by Mary Koga.)

John Dunne, Assistant Attorney General, presents Tsuneko Neeno with a redress check at the Heiwa Terrace ceremony for older recipients. All living Japanese Americans forced into concentration camps during World War II were eligible to receive redress checks. Concentrated grass roots actions resulted in 750 witnesses telling their stories at hearings by the Commission on Wartime Relocation and Internment of Civilians in 1981.

Eight

SPORTS AND
RECREATION

That Japanese Americans desired support as they attempted to merge into the wider community is reflected in their attendance at community events. More than 3,000 frequented a picnic and 800 viewed movies. It was the time of clubs with more than 110 groups established between 1945 and 1952 by Abe Hagiwara. The Chicago Nisei Athletic Association (CNAA) formed in 1946 had 1,200 participants at its height with programs for basketball, softball, tennis, swimming, and golf. Girls Clubs were created and often sponsored dances and social events. The Midwest Haiku Club started in 1946. There were gatherings for special groups such as war brides and Hawaiians. Interest groups such as Senryo poetry, bowling, koto, and investments formed. Children's activities such as scouting or the Drum and Bugle Corps became family events with strong parental support. Participating in wholesome sports and recreational programs was a fun way to develop fellowship and support.

Pictured, left to right, are the following: William Kaufman, Tom Watanabe, unknown, Hikaru Nagao, and Yoshitoro Sakai. Judo's giving way to force instead of going against force was appealing to Tak Mizuta and he made that his philosophy of life. (Photograph by Tak Mizuta.)

Masato Tamura at his retirement. In 1941 Tamura came to Chicago from Tacoma, Washington, to join the Ji Jitsu Institute owned by Harry Auspitz. Tamura became well known in 1943 when he knocked out professional wrestler Karl Pajello—who weighed 205 pounds to Tamura's 143 pounds—in one minute ten seconds. The U.S. Navy then taught Ju Jitsu self-defense techniques to American soldiers. Tamura became the first President of Chicago Yudanshakai or Chicago Black Belt in 1949 with a charter from Kododan in Japan. Ji Jitsu means art of gentleness and promotes efficient use of mental and physical energy. (Photograph by Tak Mizuta.)

Guests at Tamura Party include, from left to right, Paul and Phyllis Harper, Masato Tamura, Jim Colgan, Hikaru Nagao, Mayeda, William Kaufman, Miyazaki, Kenji Okamoto, Henry Okamura, and Yoshitaro Sakai. Judo started at the Lawson YMCA when Hank Okumura and Kenji Okamoto practiced there and taught it to many Chicagoans for many years. This martial art has become very popular with those of many ages and ethnic backgrounds. (Photograph by Tak Mizuta.)

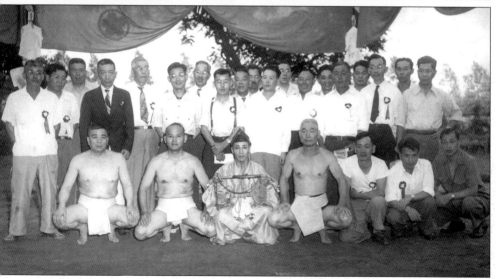

Top Left: Maedayama, a 310-pound former sumo grand champion, was a guest at the Chicago Resettlers Committee Picnic on September 4, 1951. (Courtesy of Elsa Higashide.)

Top Right: Koichi Matsumoto and George Saiki at a Sumo event held on the block behind Division Cleaners in 1947. (Courtesy of Jane and Richard Hidaka.)

Bottom: Koichi Matsumoto came from a family of well-known sumo wrestlers including his grandfather, cousin, and younger brother. Mr. Matsumoto liked to invite guests to the backyard of his boarding house at 3949 S. Lake Park to participate in sumo. He acted as referee in this 1946 event. (Courtesy of Kubose Family.)

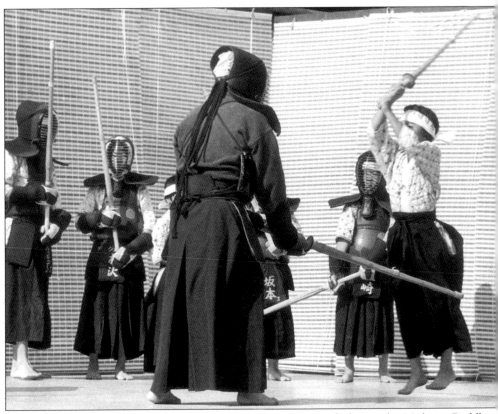

A Kendo, or Japanese fencing, demonstration showing an attack during the Midwest Buddhist Church's Ginza Festival in 1950s. Kendo originated as training for samurai. (Photograph by Ken Mazawa.)

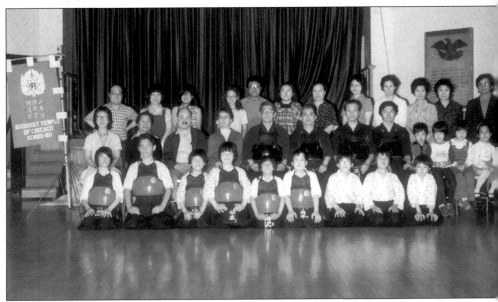

Chicago Kendo Dojo, Junior Group in 1981. (Courtesy of Ken Kikuchi.)

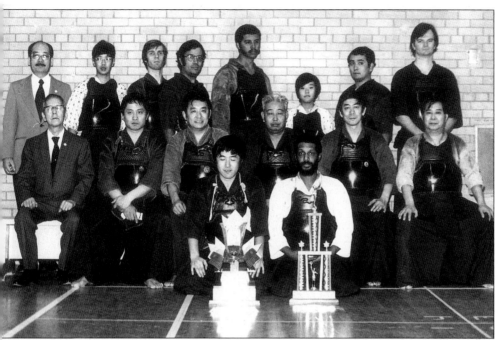

Chicago Kendo Dojo showing their winning trophies at the Michigan State Tournament in 1973. Pictured, from left to right, are: (front row) Shunji Munemoto and Richard Reed; (second row) Junzo Ideno, Yutako Miyazaki, Frank Matsumoto, S. Maeda, George Izui, and Stanley Kadoi; (back row) Joe Aoyagi, Allan Matsumoto, Robert Krzmienski, I. Sarabla, Lester Scates, George Uawasaki, Robert Hamano, and Robert Thompson. Kendo practice sessions are regularly held at the Buddhist Temple of Chicago. (Courtesy of Frank Matsumoto.)

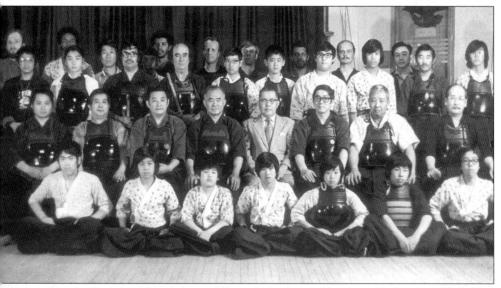

Chicago Kendo Dojo was founded in 1964, and the Junior Kendo group was established in 1965. Recently the adult kendo group has been meeting more frequently and winning more tournament awards. They also practice Iaido, the art of Japanese sword drawing. (Courtesy of Frank Matsumoto.)

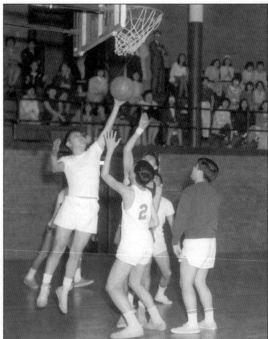

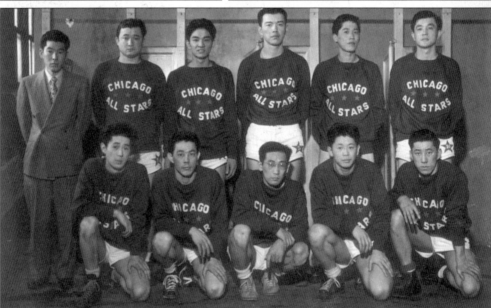

Top Left: Olivet Institute in 1945. Wallace Heistad, the director of Olivet Institute, was kind to permit use of this facility to play sports, have dances, and hold other social events. (Photograph by Bill Adachi.)

Top Right: Midwest Buddhist Church basketball team playing at Olivet Institute in 1950. (Courtesy of Ben Chikaraishi.)

Bottom: Chicago All Stars Team. (Photograph by Bill Adachi.)

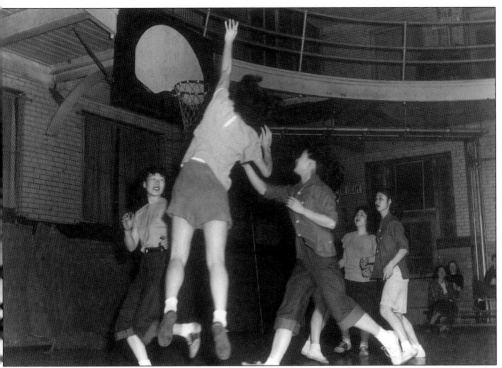

Going for a basket as the Serenes and Ting-a-lings fight for the Championship Title. They were part of the Chicago Nisei Athletic Association (CNAA) league, which was formed in 1946. At its height there were 1,200 participants in baseball, softball, golf, and tennis. (Photograph by Bill Adachi.)

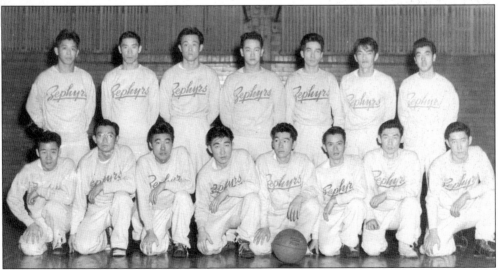

Zephyrs, the first Nisei basketball team in Chicago, were sponsored by the *Courier*, the first Nisei newspaper. They won the Double-A Championship in 1946. Pictured are: (front row) Hideo Koike, Nay Togashi, Choppy Kanazari, Jack Hamahashi, Jim Hata (coach), Bill Adachi (manager), Hiromi Sato, and Jack Hoshizu; (back row) John Kashiwabara, George Hoshizu, Tom Yokoi, Thomas Mayahara, Min Isoye, Hide Yamane, and Bob Nitahara. (Courtesy of Tom Mayahara.)

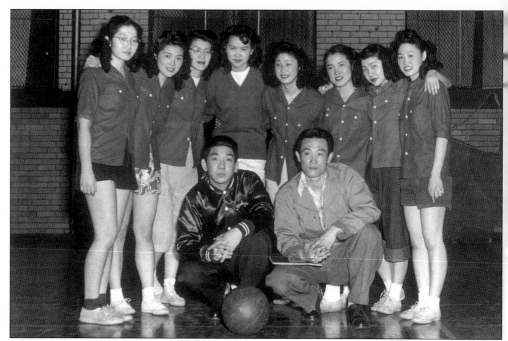

The Serenes Championship Team is pictured during their Denver trip in 1949: Mary Ann Ouye, Mary Nakase, Aiko Suzuki, Ets Mizukami, UK, Tsune Mayeda, Dottie Mizukami, Coach Frank Okuda, and Coach Tom Yokoi. (Photograph by Bill Adachi.)

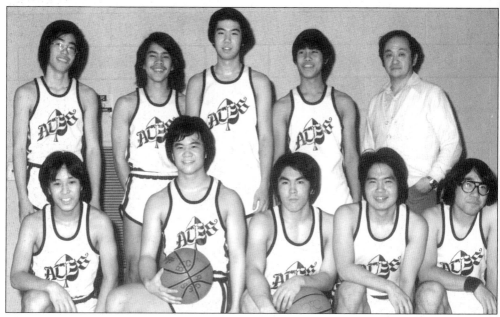

The BTC ACES 1976 team prior to their Los Angeles trip for the Invitational Tourney. They captured the CNAA Championships two years in a row. Pictured, from left to right, are as follows: (front row) Steve Ansai, Kevin Hirai, Chuck Izui, Bob Takamoto, and Glenn Itano; (back row) Steve Hamada, Glenn Guinsatao, Jeff Uchida, Jeff Kurokawa, and Tom Mayahara. (Courtesy of Tom Mayahara.)

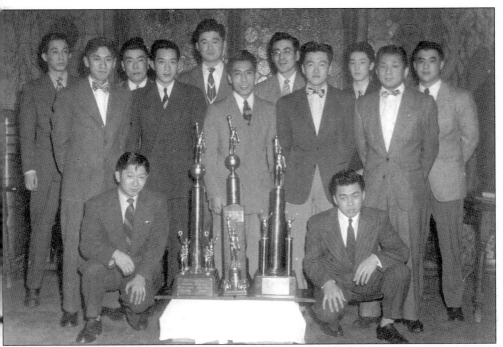

Kalifornian Award Winners in 1945. (Photograph by Bill Adachi.)

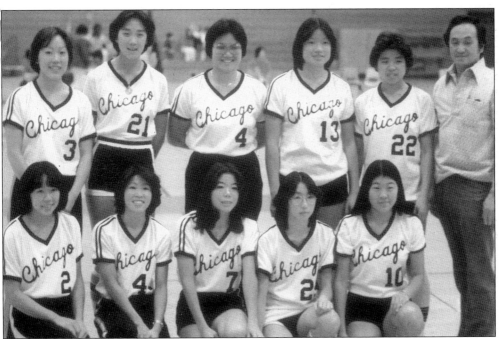

The Chicago Sundowners All-Star Team were participants in the 1977 and 1978 Los Angeles Yamasa Tournament and emerged as champions in 1978. Pictured are: (front row) Ellen Hayashi, Lynne Hayashi, Kathy Hamada, Susan Fong, and Nancy Imon; (back row) Jackie Miyake, Gloria Lee, Debbie Nakawatasae, Joan Eng, Cindy Nitahara, and Tom Mayahara. (Courtesy of Thomas Mayahara.)

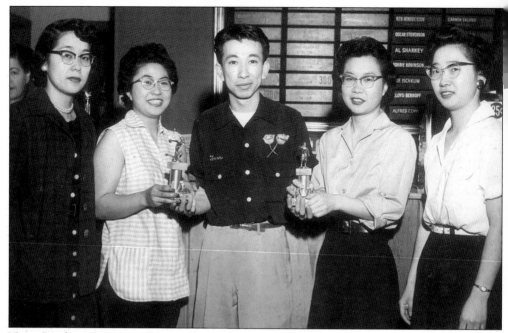

Nisei Bowling League at Marigold in the early 1950s. Kazzie Hirai, Alyce Kadota, Tom Hashimoto, Amy Morita, and Flora Morita show off their bowling trophies. Bowling leagues were available at Victory Recreation, the Gold Coast League, and Hyde Park Bowlium. (Courtesy of Kazue Mayahara.)

Below: Bowling. (Courtesy of JACL.)

Rocky Yamanaka in the Peterson Bowling Classics in 1958. (Courtesy of Alyce and Rocky Yamanaka.)

Tak Sugiyama was a talented passing, kicking, and running right halfback with the Chicago Indians football team. In 1948 this team won all eight of their games in the amateur City League competition and entered the semi-pro ranks in 1949. It was sponsored by Dale Cleaners, a Nisei-owned shop on Chicago's north side. (Photograph by Ken Mazawa.)

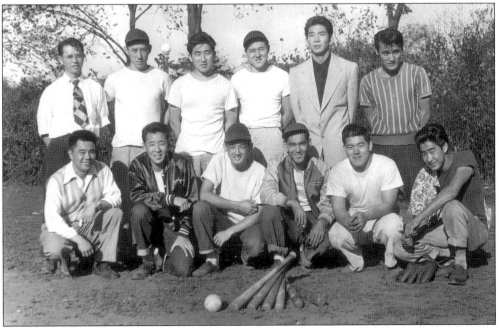

The Zephyrs were the 1948 Softball Champions of the CNAA, and in 1949 they defeated the JACL for the city title. (Courtesy of Yae and Bill Adachi.)

Pictured is the Church of Christ Presbyterian Church baseball team. From left, they are: (front row) Richard Saiki, Kenneth Saiki, J Uyeda, Kendall Itoku, Pat Endo, Eric Mizuno, Jason Miyake, Steven Sugai, Joey Uyeda, and Scott Anamizu; (back row) Coach Jim Saiki, Ase, Mitchell Amino, Chester Tanaka, Brent Saiki, Dean Matsuo, Ken Nishibayashi, Jeff Endo, and coach Ken Yozu. (Courtesy of Jean Mishima.)

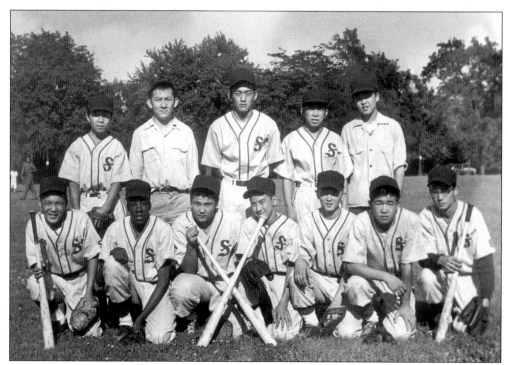

Yuki Matsumoto coached this baseball team for Jackson Park as part of the Chicago Park District Program in 1954. (Courtesy of Kubose Family.)

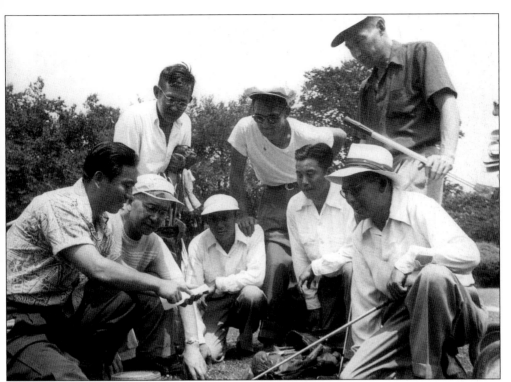

Nisei players conducted business as they participated in golf. (Courtesy of JACL.)

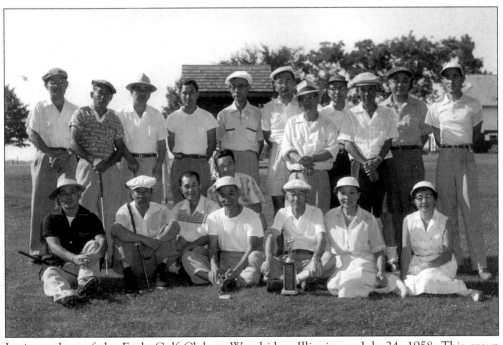

Issei members of the Eagle Golf Club at Woodridge, Illinois, on July 24, 1958. This group enjoyed playing golf into their senior years forming Super, Super Senior teams so they could compete with younger players. (Courtesy of Hiroko Nishi.)

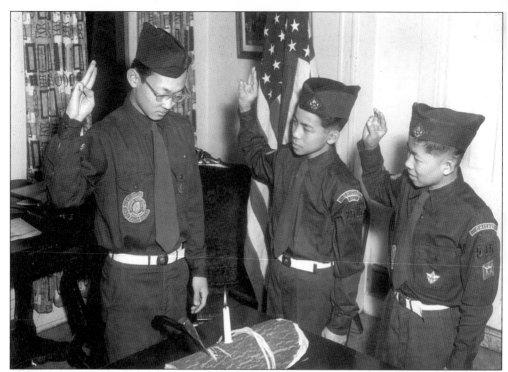

Explorer scouts Don Kubose, Kaz Ideno, and Bobby Doi taking a pledge in 1953. (Courtesy of Kubose Family.)

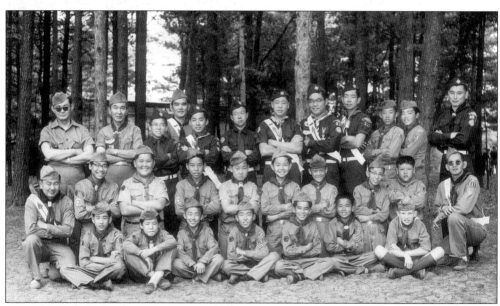

Boy Scout Troop 515 at Camp Owasippe. This troop was organized in 1947 at the Buddhist Church of Chicago and became known for its rich tradition of scouting at all levels. Don Nozawa liked camping and learning lifesaving skills. He graduated from Cub Scout to Boy Scout to Explorer Scout. A church was not only a place of worship, but served as a community center with many social activities. (Courtesy of Donald Nozawa.)

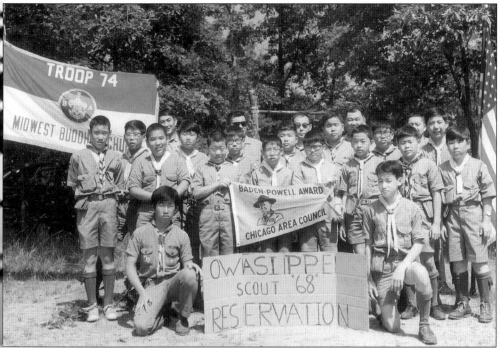

The Midwest Buddhist Church's Boy Scout Troop 74 at Camp Oswasippe won the Baden-Powell Award in 1968. (Photograph by Bill Adachi.)

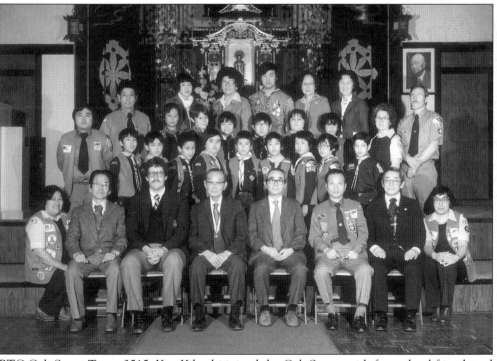

BTC Cub Scout Troop 3515. Ken Kikuchi joined the Cub Scouts with four school friends and especially liked the Jamborees and field trips to Cantigny. (Courtesy of Ken Kikuchi.)

Sport Days at Futabakai School. (Courtesy of *Chicago Shimpo*.)

Futabakai Sports Day. Futabakai is a school for children of Japanese nationals so they can maintain the level of their age group in Japan. This is important because grades and tests determine entrance into Japanese universities, which then influence employment opportunities. (Courtesy of *Chicago Shimpo*.)

114

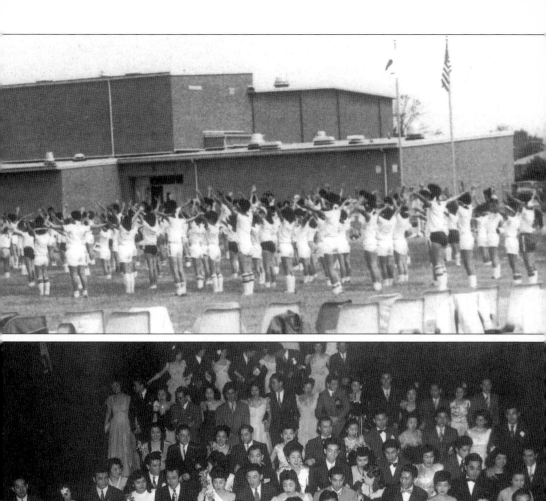

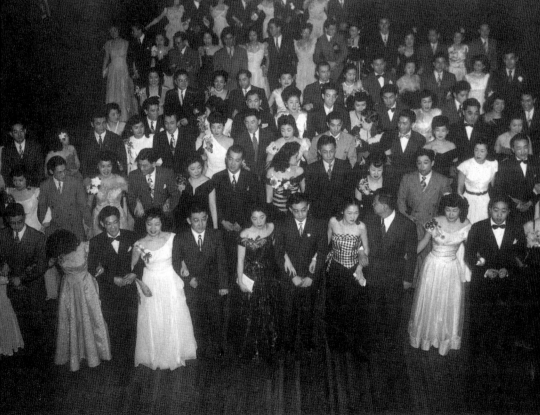

University of Chicago's International House was the location for this elegant dance in 1945. (Photograph by Bill Adachi.)

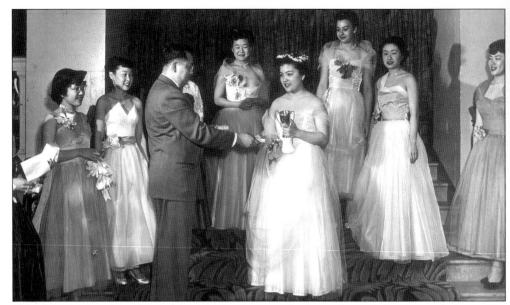

Terri Yamanaka of the Charmettes accepts the winner's trophy and floral wreath from Abe Hagiwara to become Miss Portrait of Spring. She is surrounded by her court. This event, co-sponsored by the Girls' Clubs and the Inter-club Council, was held in the elegant Tropical Room of the Sheraton Hotel in April 1948. (Photograph by Ken Mazawa.)

Inter-club Council Cabinet Members at the Sheraton Hotel Dance in 1948. The council had a newsletter and acted as a clearinghouse for the dances, parties, and social events of the Girls' Clubs. It offered educational programs, leadership training, and community activities such as graduation teas and bazaars.(Photograph by Ken Mazawa.)

Nine
ARTS AND CULTURE

Going beyond stereotypes and knowing the hearts of Japanese Americans can be gleamed through their music, art, dance, and writings. Sono Asato and Yuki Shimoda began their dance careers in Chicago. Todd Yamamoto and Doug Hashimoto continue to play jazz. Perpetuating Japanese cultural heritage continues through classical Japanese dancing, koto playing, serving tea, and now taiko drumming. Recently Nikkei seniors have enjoyed assembling to play ukuleles, sing, and dance. New sounds are being forged by James Iha and Tatsu Aoki's Big Band.

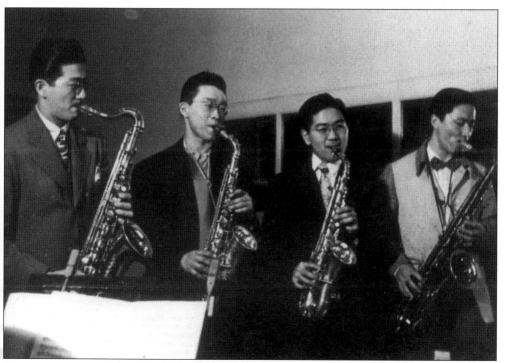

The sax section of the Nisei Music Makers included Tug Tamaru, George Yoshida, Tad Yamamoto, and Yuki Miyamoto, 1944. Yamamoto was interned at Gila River Camp from Santa Barbara. In 1943 he attended the Chicago Musical College and while there organized the Nisei Music Makers. (Courtesy of the Chicago Japanese American Historical Society, Yoshida Collection.)

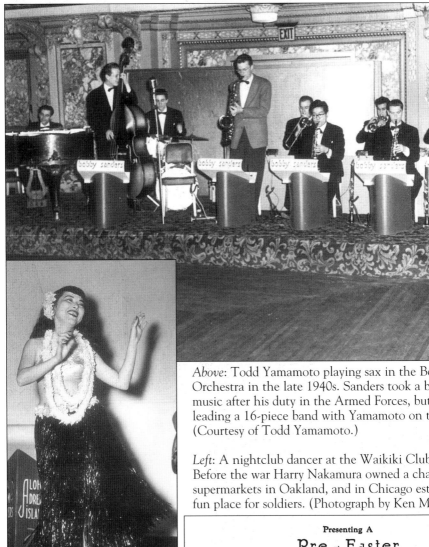

Above: Todd Yamamoto playing sax in the Bobby Sander Orchestra in the late 1940s. Sanders took a break from music after his duty in the Armed Forces, but is currently leading a 16-piece band with Yamamoto on the sax. (Courtesy of Todd Yamamoto.)

Left: A nightclub dancer at the Waikiki Club in 1952. Before the war Harry Nakamura owned a chain of supermarkets in Oakland, and in Chicago established this fun place for soldiers. (Photograph by Ken Mazawa.)

Right: A flyer for a dance held at the Midland Hotel shows a cost of $1.50 for gents. Ladies could enter free since the men greatly outnumbered the women. Dancing was a popular way to socialize and make new friends. (Courtesy of the Chicago Japanese American Historical Society, Yoshida Collection.)

Presenting A

Pre - Easter

DANCE

Music by Chicago's
NISEI
MUSIC MAKERS
12 PIECE BAND
— ❦ ❦ ❦ —

HOTEL MIDLAND

GRAND BALL ROOM, — 172 WEST ADAMS STREET

SATURDAY, APRIL 1st, 1944

"HEART OF THE LOOP"

Tickets Available At The Door, 8:30 P. M. till 1:30 A. M.

Admission - Gents $1.50 Inc. Fed. Tax

Sponsored By AMERICAN NISEI ATHLETIC CLUB

Yuki Shimoda autographed this photograph for Rev. Gyomay Kubose. Shimoda was raised in Sacramento but came to Chicago to study after he was released from Tule Lake Relocation Camp. Shimoda started his career at the Chicago Opera and then went to New York to perform musicals such as *Auntie Mame*, *The King and I*, and *South Pacific*. He also starred in several movies such as *Farewell to Manzanar*, *Midway*, and *MacArthur*. (Courtesy of the Kubose Family.)

Sono Osato was a ballerina with the Ballet Russe de Monte Carlo from 1934 to 1940 and with the American Ballet Theatre until 1943. Her stage performances included *One Touch of Venus*, *On the Town*, *Ballet Ballads*, *Peer Gynt*, and *Only Over Lightly*. She danced in the movie *Kissing Bandits* starring Frank Sinatra. (Courtesy of Chicago Japanese American Historical Society, Strength and Diversity Collection.)

Far Left: Wakayaga Shiyu taught children Japanese classical dance beginning in 1962 at a nominal cost in order to perpetuate Japanese culture. The dancers made many appearances, such as at Japan Day at Daley Center, Botanic Garden Japan Festivals, Auditorium Theater, Chicago International Folk Fair, and Christmas Around the World at the Museum of Science and Industry. They also danced in other states and countries. (Courtesy of Mitsu and Ted Uchimoto.)

Immediate Left: Fuji Musume dancer, October 8, 1925.

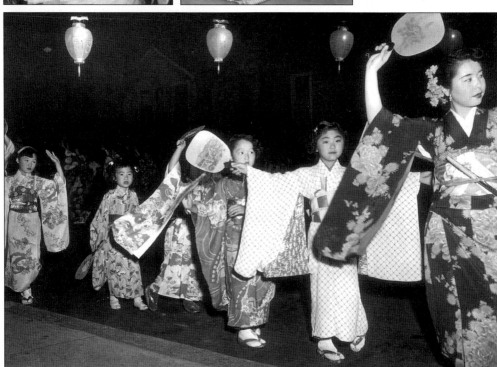

The Buddhist Temple of Chicago's Obon Festival, or Festival of the Dead, in summer 1949, with chochin paper lanterns decorating the dance area. (Photograph by Ken Mazawa.)

Far Right: Kikayo Tsubouchi leads Japanese dancing with her daughter Takayo at the Annual Labor Day Picnic. (Photograph by Ken Mazawa.)

Immediate Right: The Midwest Buddhist Temple Minyo group danced at the Field Museum as part of the Strength and Diversity Exhibit performances in 1995. (Photograph by Nobuko Oyabe.)

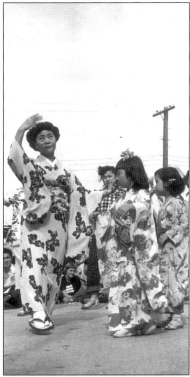

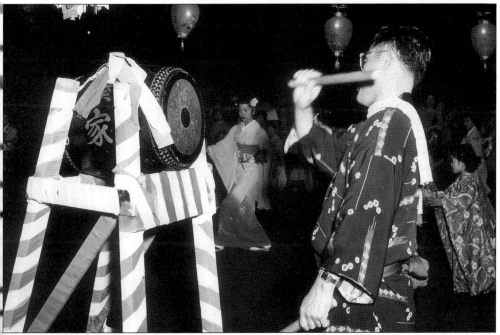

Drummer stands on the yagura wooden stage to make music at the BTC's Obon Festival in 1949. Ancestral spirits have been welcomed back for annual summer visits for 1,500 years. This is a way to remember those who proceeded us and to express gratitude to them. (Photograph by Ken Mazawa.)

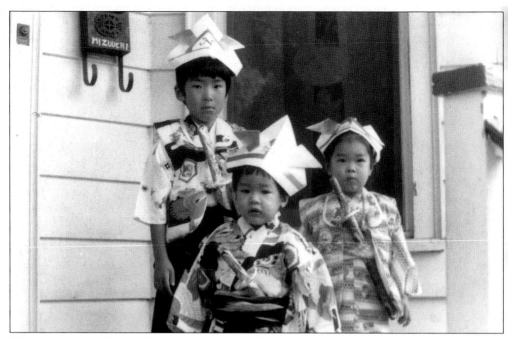

The Mizuuchi children celebrated *Tango no Sekku* on May 5th by dressing in Samurai outfits including kabuto hats and learning about the Samurai way of life. Prior to World War II this holiday was called Boys Day, but in 1948 it was changed to *Kodomo-no-hi* or Children's Day by the U.S. Occupation Forces under MacArthur to de-emphasize feudalism.

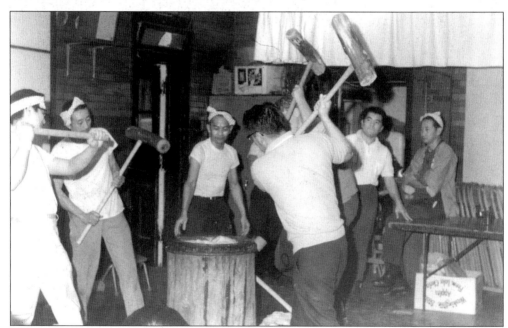

Mochitsuki, or rice pounding, by the Midwest Buddhist Church. Done prior to *Oshogatsu* or New Year's Day using kine mallets and usu, usually made of stone. Omochi is eaten for good luck and prosperity in the following year. Two mochi with a tangerine on top is presented to the kami on a Buddhist altar. (Photograph by Bill Adachi.)

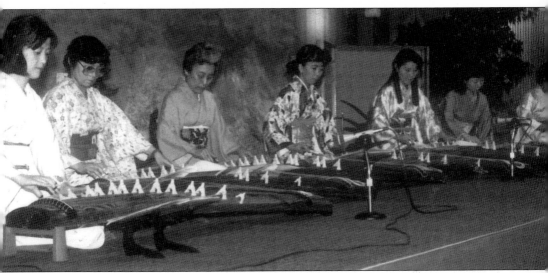

The Chicago Koto Group, founded in 1985, perform at many events. (Courtesy of *Chicago Shimpo*.)

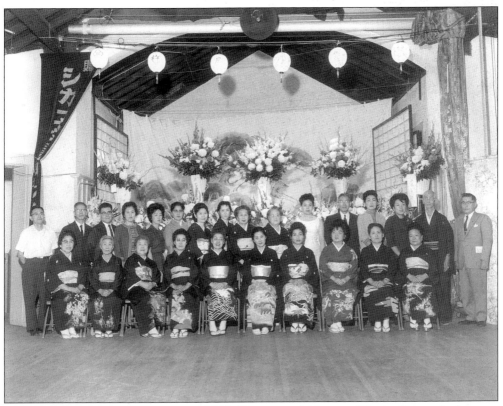

Tsukake Fukujusha's singing group in 1963. (Courtesy of Alyce and Rocky Yamanaka.)

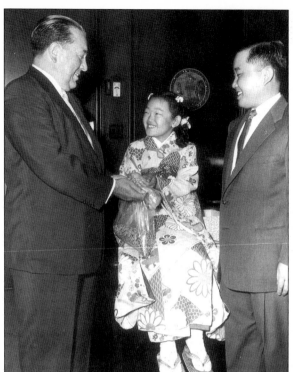

Joyce Kubose felt happy and proud to represent the children of Japan in giving cherry seeds to Mayor Daley in 1955. She was impressed as she was lifted onto the mayor's desk that there were a lot of papers there. She liked being in a kimono and feels this was the beginning of her love for Japan, kimono, and *chanoyu* (tea ceremony). (Courtesy of Kubose Family.)

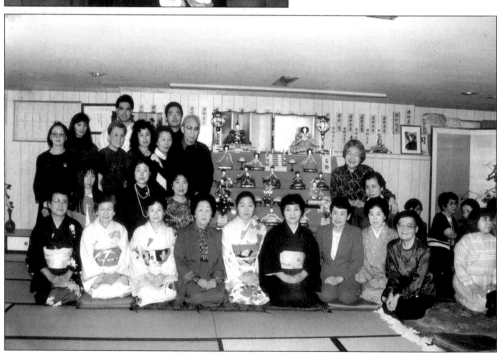

More than 160 ladies were Uchimoto guests on Hinamatsuri Girls' Day when girls display dolls. The Odairisama contains the prince and princess dolls in ancient costumes with court ladies, warriors, musicians, and dowry items symbolic of happiness. (Courtesy of Mitsu and Ted Uchimoto.)

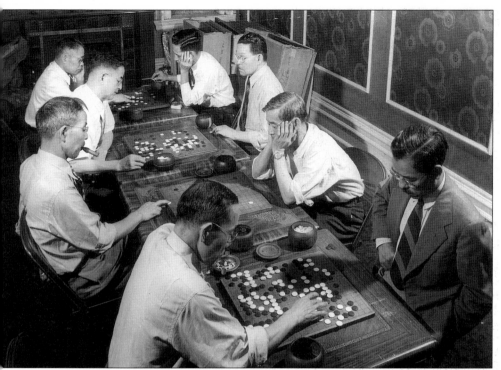

Goh or Japanese chess tournament at Chicago Resettlers in 1948. This is an ancient game symbolizing the never ending battle between the black crow and white heron. (Courtesy of Japanese American Citizens League.)

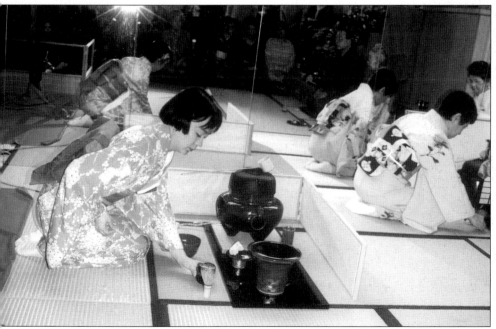

Chanoyu or Tea Ceremony is a spiritual practice of making and sharing a bowl of tea. (Courtesy of Mitsu and Ted Uchimoto.)

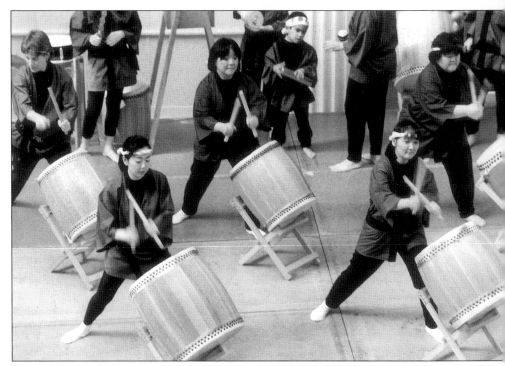

BTC Taiko Drums at the Field Museum as part of the Strength and Diversity exhibit performances in 1995. In the last 25 years, taiko has become a very popular way to express culture. (Photograph by Nobuko Oyabe.)

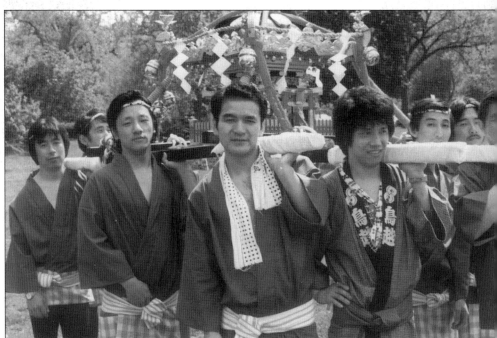

Mikoshi at the Japan Today celebration in Grant Park in 1979. This Mikoshi has been carried in many Chicago parades and festivals. (Courtesy of Mitsu and Ted Uchimoto.)

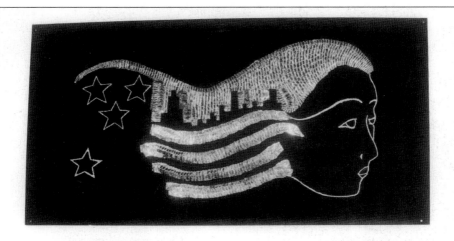

STRENGTH & DIVERSITY
JAPANESE AMERICAN WOMEN 1885 - 1990

More than a thousand cranes were origami folded by Chicago area Nikkei women in 1995 and fashioned by Betty Morita into the Strength and Diversity logo, designed by Jan Okabe Anderson. (Photograph by Alice Murata.)

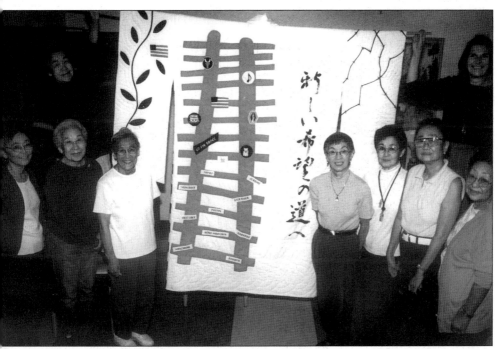

The *Chicago is Home* quilt made by Chicago Japanese American women in 2001 was on display at the Museum of Contemporary Art in October 2001 as part of the Reminiscing in Swingtime exhibit. Since November 2001, it has been on display at The Field Museum on the first floor as part of the Living Together Exhibit. (Photograph by Alice Murata.)

James Iha started Smashing Pumpkins with Billy Corgan in the late 1980s and had multi-platinum hits with *Siamese Dream* and *Mellon Collie and the Infinite Sadness*. He recorded a solo release, *Let It Come Down* in his Chicago basement studio on the Virgin Label and opened Stratosphere Recording Studio in Manhattan with Adam Schlesinger and Andy Chase of Fountains of Wayne. (Courtesy of Toshi and Kiyo Iha.)

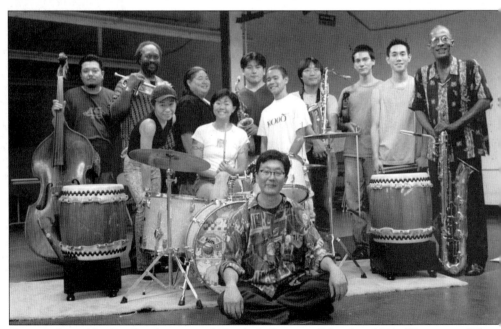

Tatsu Aoki and his Big Band premiered "Rooted: Origins of Now" in 2001. (Courtesy of Tatsu Aoki.)